1 C / G

GLOUCESTER MASSACHUSETTS

1 C / G

ONE-COLOR GRAPHICS
THE POWER OF CONTRAST

SELECTED BY CHEN DESIGN ASSOCIATES

ROCKPORT PUBLISHERS

First published in the United States of America by
Rockport Publishers, Inc.
33 Commercial Street
Gloucester, Massachusetts 01930-5089
Telephone: (978) 282-9590
Fax: (978) 283-2742
www.rockpub.com

ISBN 1-56496-923-1

10 9 8 7 6 5 4 3 2 1

Design: Chen Design Associates, San Francisco, CA

Printed in China

To Pam, Rachel, and Ethan, who have patiently
spent many late nights without me.

Thanks to all the gifted people past and present who
have contributed their passions to CDA. We're privileged
and honored to cross creative paths with you.

Thank you to Kristin, David, and Cora at Rockport
Publishers for the support; to Jo, Matt, and Michael
for helping us on judging day; and all the designers
whose projects are included in this collection —
thank you for your inspiration.

JC

DEDICATION

CONTENTS

NEXT PAGE

THE POWER OF ONE

The first man on the moon

A young John Jr. saluting his father's coffin

The invention of the wheel

Rosa Parks's refusal to move from her seat

A Shakespearean monologue

A solitary student facing a tank in Tiananmen Square

One person believing the earth is round

LIMITS. EVERYONE HATES THE WORD.
Do you drive the speed limit? Are we encouraged as children to settle for less? "More is better," "The sky's the limit," and "You can have it all!"—these are just a few of the cultural values we blindly inherit from the dreamers who preceded us. As creatives, why settle for just one color when we can have four, or six, for that matter? We're out there to create award-winning, stand-out work— why close ourselves to the options available in this age of limitless technology? We're armed with a stackful of Pantone swatchbooks and an infinite array of CMYK color combinations, waiting to be employed by our imaginations. Isn't more color the better way to captivate and impress our audiences? After all, don't our clients come to us for more than the unimaginative, quick and dirty, one-color results a quick copy shop can churn out "while-u-wait"?

But this, of course, is not the kind of one-color design this book is about. Our responsibility as visual communicators is to strive for higher standards in the face of the ubiquitous forces that would have us settle for the lowest common denominator. It is not our job to please everyone on the committee. We expect you will be inspired in the following pages by the ability of designers from all walks of life to push beyond preestablished views of what one-color design should be. As designing authors, we have sought to embody this in both the design of the book itself and the respectful presentation of the work we have selected to feature.

LET'S BE CLEAR. ONE-COLOR IS NOT:
Easier, instant, weak, restrictive, amateur, boring, simplistic, lukewarm, low-end.

ONE-COLOR IS:
Harder, striking, distinct, simple, memorable, rarely good, resourceful, intelligent—and oftentimes: ambitious, provocative, beautiful, edgy, jarring, witty, convicted, passionate.

In a world where so many forms of media vie for our attention—from our littered urban landscape of billboards to radio and television commercials surpassing ever-more over-the-edge tactics to wake us up out of our numbness just to remember a brand name or a number to "call now!"—it is imperative for us as creative people to strive for integrity in our work and to seek a higher standard for our craft.

It is our hope that this book becomes part of our industry's collective reach for excellence. We at Chen Design Associates were privileged to participate in this continuing dialogue by serving as jurors, authors, and designers of this book. To make our selections, our team exercised a rigorous system of judging over 1,000 submissions from around the world. We undertook an intense two-day process of critically considering each piece individually, voting silently, followed by in-depth group discussions for pieces that received mixed reviews. This open discussion became spirited at times, but allowed for some projects to be included that otherwise might have been overlooked. Our firm values collaboration and the strengths that each individual brings to the table, so this was an important part of our judging process.

Each selected piece was chosen because of its ingenuity, professionalism, and ability to demonstrate the power of design—with the central criterion of having used only one color on press. Non-ink processes such as emboss/deboss, blind hits, foil, die-cuts, and varnishes were acceptable, as were off-press ink techniques such as rubber stamping and laser printing. We divided the selected projects into the following five categories.

ORIGINS: THE CORE IDENTITY

These are pure presentations of corporate and organizational identities. How do you best capture the essence of what you are about in a single mark, or create a statement as captivating as possible in the dimensions of a business card, using only one color? The examples of identity systems and logos in this section demonstrate a cost-effective brilliance.

SCION: COLLATERAL OFFSPRING

This is the stuff that flows out of a foundational identity—everything from brochures and newsletters to marketing promotions and annual reports. These projects often have limited budgets. There is no lack of imagination here, however. Find out what can be done for a range of projects to arrest and engage an audience with just one color.

MACRO: DETAILS AT A DISTANCE

In this chapter we look at the large-scale impact of one-color designed posters, promotions, and other creative works for music, festivals, public service, health awareness, and theater. See what you never thought could be done with minimal ink at maximum size.

MICRO: AN INTIMATE IMPRESSION

We received so many stellar invitations and event pieces that we created a section just for them. There is something special about receiving a printed piece that speaks of quality and tactility. You view it up close, hold it in your hand, and are immediately involved with this small work of art.

VOLUME: THE THIRD DIMENSION

You've left the flat realm behind and entered the world of objects and packaging, books, music, fashion, and food. Can one-color have shelf presence in the marketplace? How does one-color design unify the complexities of volume and media other than paper and ink?

So run to it. Don't be scared of taking on that limited budget. Read on and be inspired. Let this book be a rejuvenating oasis for your mind and eye's imagination. And the next time that non-profit or small business you feel utterly passionate about has work to be done, attack the challenge of one-color with confidence. The creative possibilities (or limitations) are what you make them. You may very well discover that the best way to get your corporate client's message across is to reduce their vision of four-color, overproduced gloss to one-color, elegant uniqueness.

— Josh Chen and the Chen Design Associates team

ORIGINS
THE CORE IDENTITY
letterhead / business card / envelope / logo

CLIENT. A Day in May Design
ART DIRECTORS/DESIGNERS.
Eve Billig, Lesley Hathaway

TOOLS. QuarkXPress, Illustrator
PAPER. Classic Crest
PRINTING. Full Circle Press

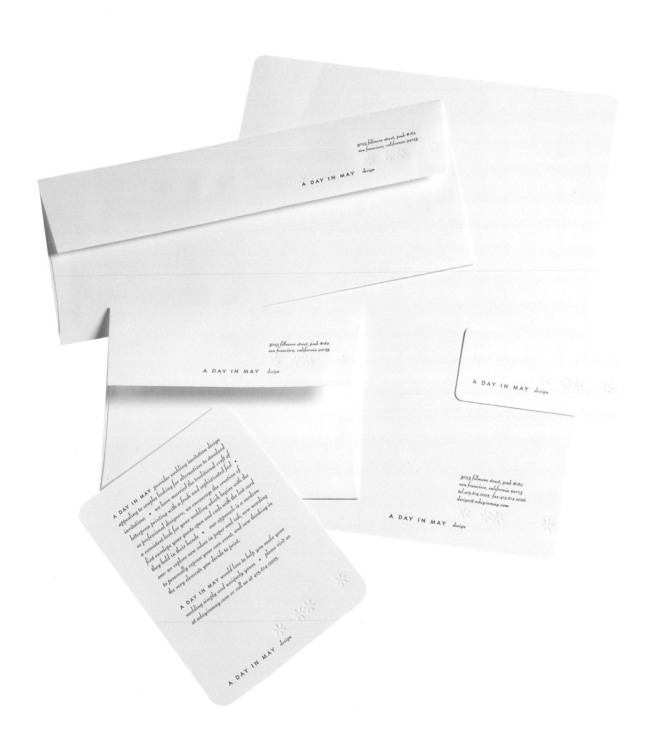

CLIENT. Jill Savini
ART DIRECTOR/DESIGNER. Jill Savini

TOOLS. Illustrator, Macintosh
PAPER. Crane's
PRINTING. Full Circle Press

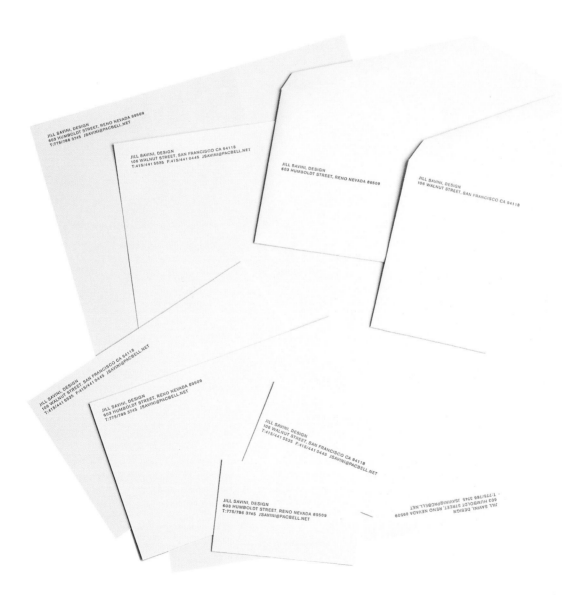

AGD Communications, Inc. Corporate and Financial Public Relations

AGD Communications
395 Riverside Drive
New York, NY 10025

395 Riverside Drive New York, NY 10025 Tel 212.864.0000 Fax 212.663.3888
e-mail: ADee@agdcomm.com www.agdcomm.com

CLIENT. AGD Communications, Inc.
ART DIRECTOR. George Tscherny
DESIGNERS. George Tscherny, Matthew Cocco

TOOL. QuarkXPress
PAPER. Neenah Classic Crest
PRINTING. The Thomas Group

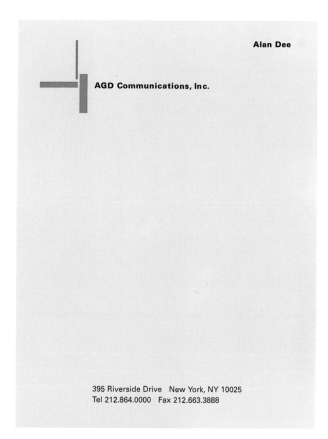

Alan Dee

AGD Communications, Inc.

395 Riverside Drive New York, NY 10025
Tel 212.864.0000 Fax 212.663.3888

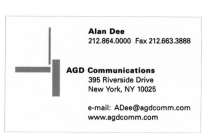

Alan Dee
212.864.0000 Fax 212.663.3888

AGD Communications
395 Riverside Drive
New York, NY 10025

e-mail: ADee@agdcomm.com
www.agdcomm.com

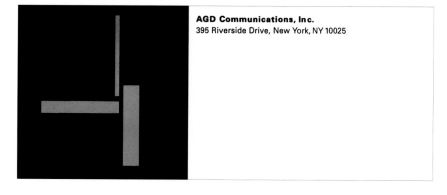

AGD Communications, Inc.
395 Riverside Drive, New York, NY 10025

★★★Suzanne George identity

Elixir Design

CLIENT. Suzanne George
ART DIRECTOR. Jennifer Jerde
DESIGNERS. Jennifer Jerde, Holly Holmquist, Nathan Durrant

ILLUSTRATOR. Thomas Hennessy
PAPER. Fabriano, Crane's
PRINTING. Dickson's, Inc., Elizabeth Hubbell Studio

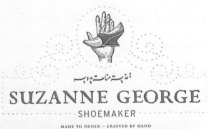

SUZANNE GEORGE
SHOEMAKER

MADE TO ORDER – CRAFTED BY HAND

POST OFFICE BOX 591268 SAN FRANCISCO CALIFORNIA 94159

TEL 415 775 1775 SUZSHOES@SIRIUS.COM FAX 415 387 3778

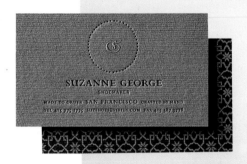

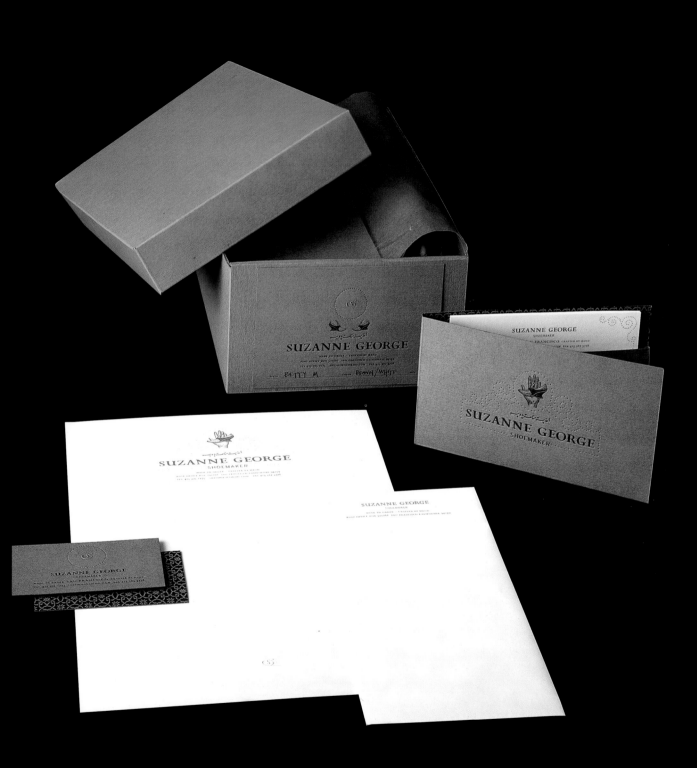

★★★Freed Arnold Architecture identity

Nassar Design

CLIENT. Freed Arnold Architecture
ART DIRECTOR. Nelida Nassar
DESIGNER. Margarita Encomienda
TOOL. QuarkXPress
PAPER. Neenah UltraWhite, Curious
PRINTING. Offset

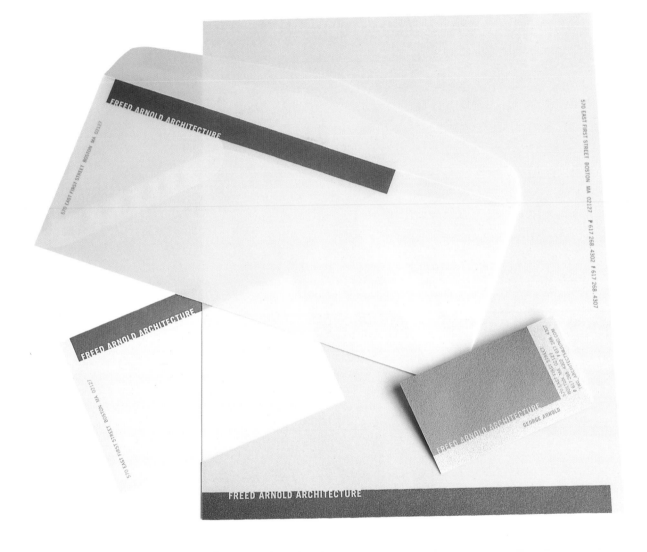

CLIENT. Tabu Nightclub
DESIGNER. Jeff Matz

TOOLS. Illustrator, QuarkXPress
PAPER. Classic Crest Solar White
PRINTING. Offset

★★★Tabu identity

Lure Design, Inc.

19
1C/

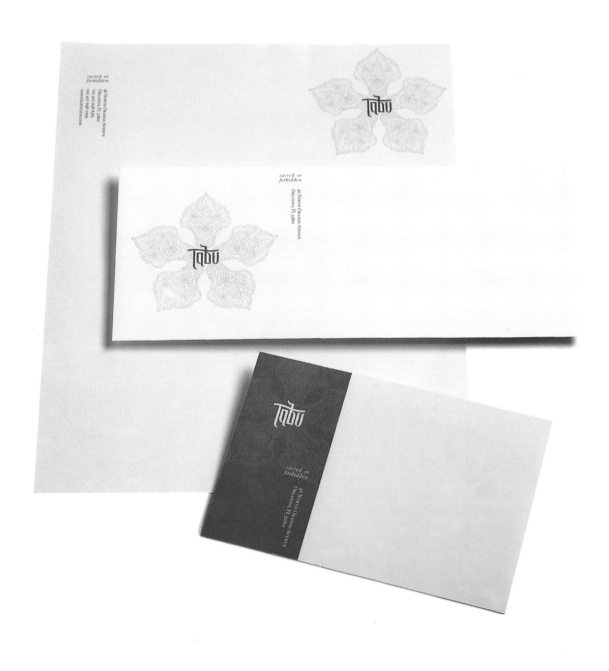

C / G

★★★Art Center College of Design Alumni Council logo

Gee & Chung Design

CLIENT. Art Center College of Design Alumni Council
ART DIRECTOR/DESIGNER/ILLUSTRATOR. Earl Gee
TOOLS. Illustrator, Macintosh

CLIENT. Art Center College of Design Alumni Council
ART DIRECTOR/DESIGNER/ILLUSTRATOR. Earl Gee
TOOLS. Illustrator, Macintosh

CLIENT. Jorge Silvetti
ART DIRECTOR/DESIGNER. Nelida Nassar

TOOLS. Hand typeset
PAPER. Crane Crest
PRINTING. Engraving

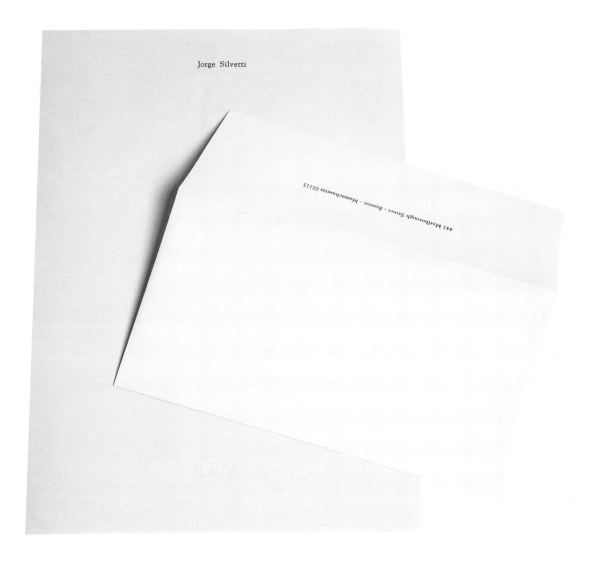

Jorge Silvetti

443 Marlborough Street - Boston - Massachusetts 02115

CLIENT. High Watch Farm

ART DIRECTOR. Steve Barretto

DESIGNER. Leonardo Calderón

TOOLS. Illustrator, Macintosh

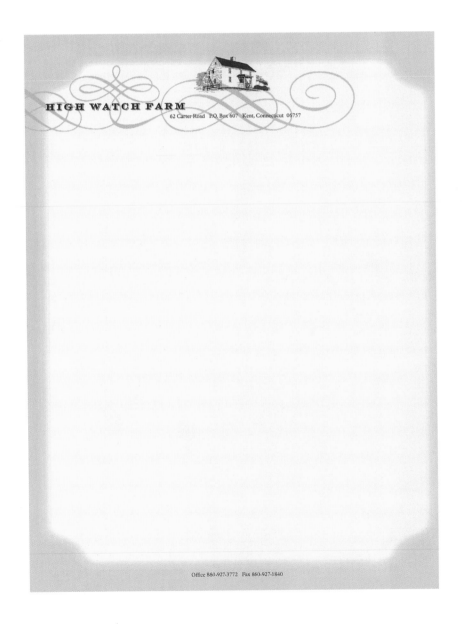

HIGH WATCH FARM

62 Carter Road P.O. Box 607 Kent, Connecticut 06757

Office 860-927-3772 Fax 860-927-1840

cão+

★★★José J. Dias da S. Junior
business card
José J. Dias da S. Junior

ORIGINS
23
1 C/

CLIENT. José J. Dias da S. Junior
DESIGNER. José J. Dias da S. Junior
TOOLS. Corel Draw, PC
PAPER. Color Plus
PRINTING. Offset silver

criação+design

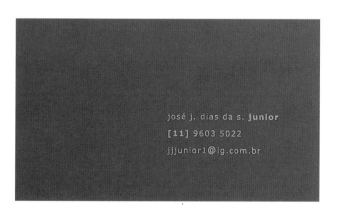

josé j. dias da s. junior
[11] 9603 5022
jjjunior1@ig.com.br

★★★Carnahan Landscape identity

Choplogic

CLIENT. Bruce Carnahan Landscape Design, Inc.
ART DIRECTOR/ILLUSTRATOR. Walter McCord
DESIGNERS. Walter McCord, Mary Cawein

TOOLS. QuarkXPress, Macintosh
PAPER. Mohawk Superfine
PRINTING. Offset lithography

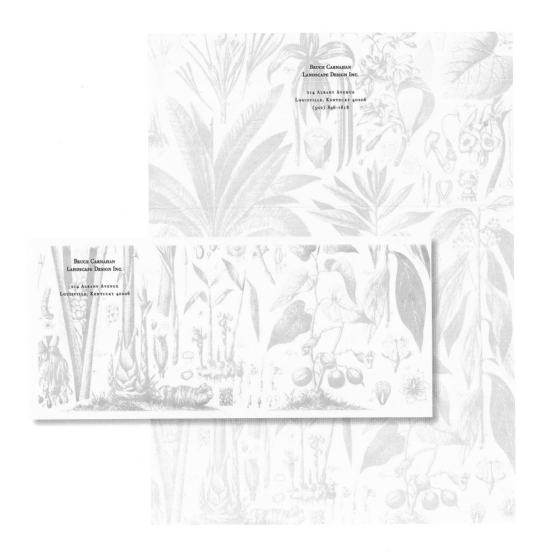

CLIENT. Elixir Design
ART DIRECTOR. Jennifer Jerde
DESIGNERS. Jennifer Jerde, Nathan Durrant
PAPER. Curious Popset
PRINTING. Dickson's, Inc.

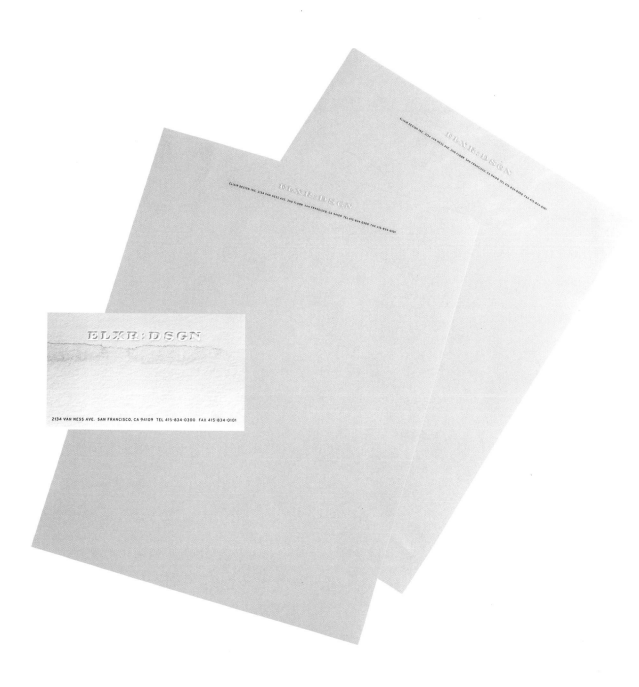

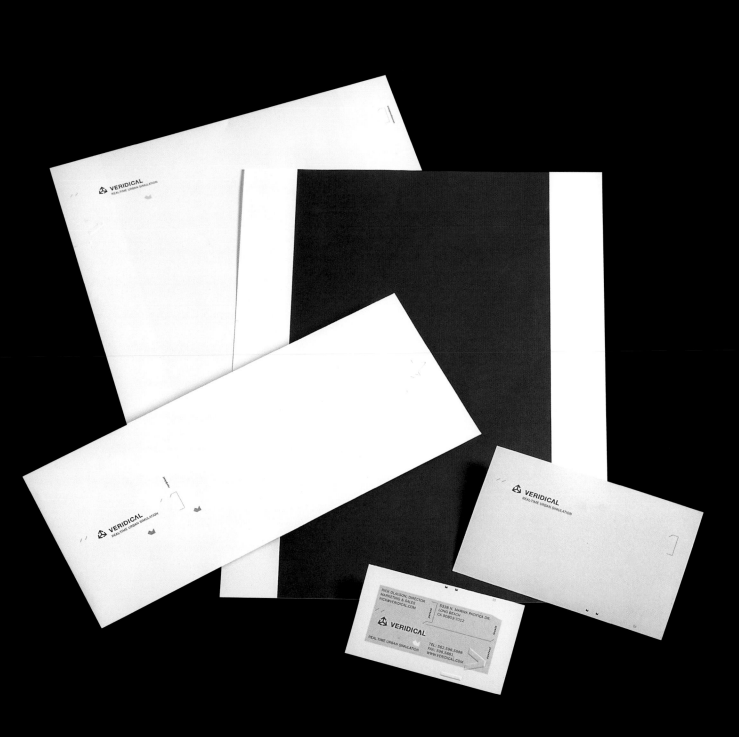

CLIENT. Veridical
ART DIRECTOR. Bill Cahan
DESIGNER. Todd Simmons

TOOLS. Illustrator, QuarkXPress
PAPER. Neenah Classic Crest

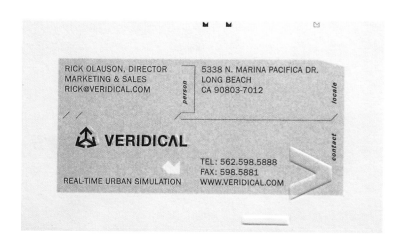

★★★Castor Henig identity

Elixir Design

CLIENT. Castor Henig Architecture
ART DIRECTOR. Jennifer Jerde
DESIGNERS. Holly Holmquist, Jennifer Jerde
PAPER. Fabriano (bcard), Crane's (ltrhd)
PRINTING. Dickson's, Inc.

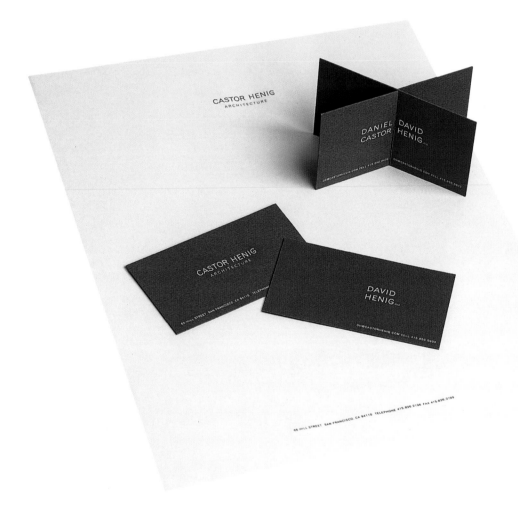

CLIENT. Campion Wines **ILLUSTRATOR.** Mike Gray **PAPER.** Mohawk Superfine
ART DIRECTOR. Tony Auston **TOOLS.** Illustrator, Softwhite
DESIGNER. Don Whelan Photoshop, Macintosh **PRINTING.** Dickson's, Inc.

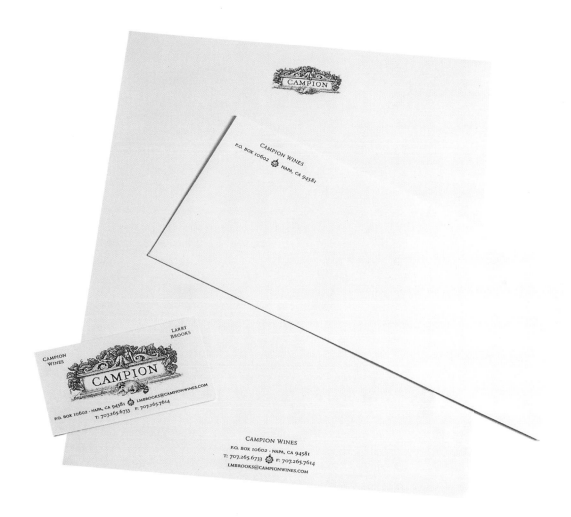

★★★2001 Dogwood Festival logo

Jeanne Macijowsky Design

CLIENT. 2001 Dogwood Festival
ART DIRECTOR/DESIGNER. Jeanne Macijowsky
TOOLS. Illustrator, Photoshop

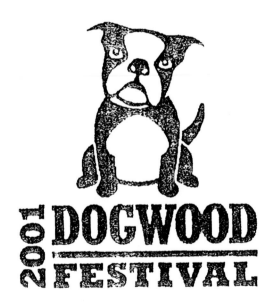

CLIENT. Form Fünf
DESIGNERS. Ulysses Voelker,
Daniel Bastian, Martin Veicht

TOOLS. QuarkXPress, Fontographer
PAPER. Gohrsmühle Bankpost 100g
PRINTING. Offset lithography

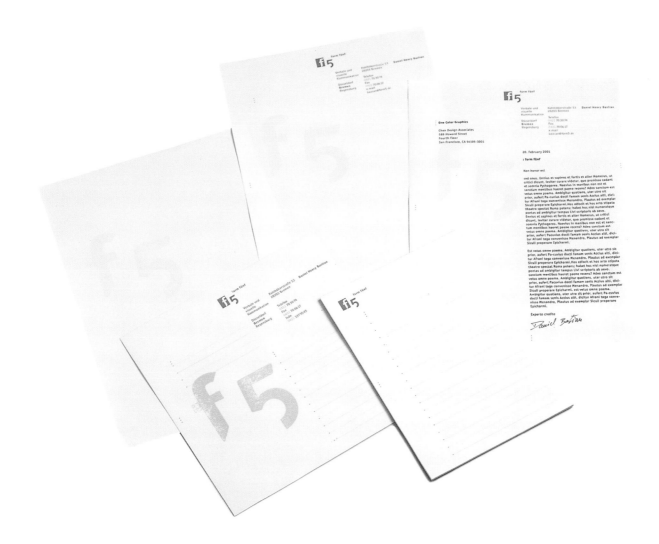

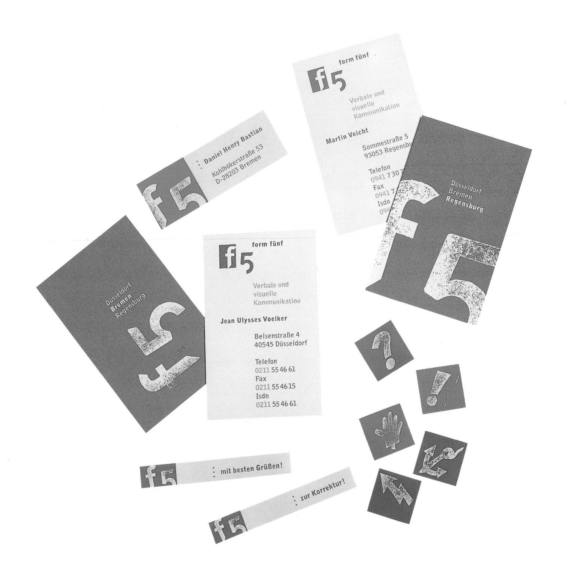

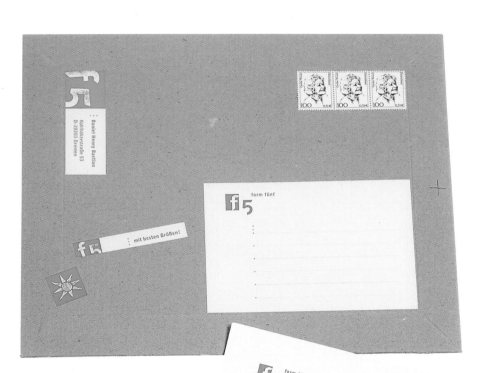

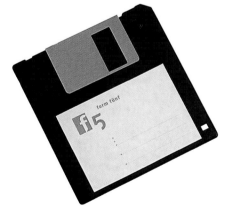

★★★Knoll media kit

Decker Design

CLIENT. Knoll
ART DIRECTOR. Lynda Decker
DESIGNERS. Lynda Decker, Matt Hamlin
TOOLS. QuarkXPress, Illustrator
PAPER. Strathmore Pinstripe
PRINTING. Dickson's, Inc.

CLIENT. David Elinoff
ART DIRECTOR/DESIGNER.
Aaron Cruse

MATERIALS. Glassine, 16-mm Film
Leader, Player Piano Roll Paper
PRINTING. Silkscreen

★★★David Elinoff business cards
Dead Letter Type

ORIGINS 35
1 C/

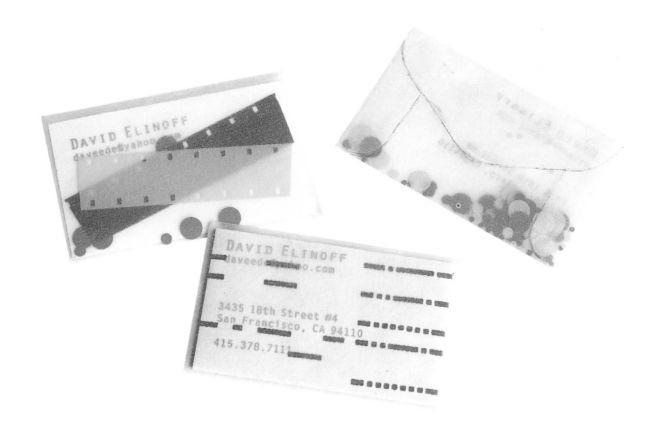

★★★EyeCandyTV.com biz card

Bløk Design

CLIENT. EyeCandyTV.com
ART DIRECTOR. Vanessa Eckstein
DESIGNERS. Vanessa Eckstein, Frances Chen

TOOLS. Illustrator, Macintosh
MATERIALS. Plastic, Chromatica
Transparent, Strathmore
PRINTING. C.J. Graphics

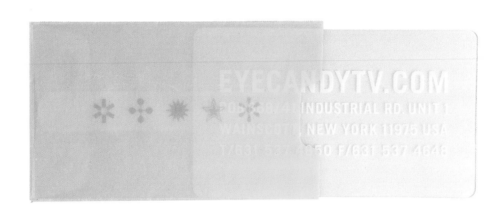

CLIENT. Bowhaus Design Groupe
ART DIRECTOR/DESIGNER. Matt O'Rourke
TOOL. Illustrator

★★★Openhaus logo
Bowhaus Design Groupe

ORIGINS
37
1 C

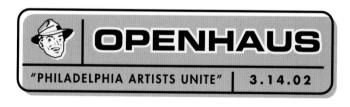

★★★Brophy identity

Drive Communications

CLIENT. Donna Lynn Brophy Photography
ART DIRECTOR. Michael Graziolo
DESIGNERS. Tim Goldman, Michael Graziolo

TOOLS. Illustrator, Photoshop, Macintosh
PAPER. Champion Carnival Yellow (text, cover)
PRINTING. Letterhead and postcard printed
black. Red rubber stamp on all pieces.

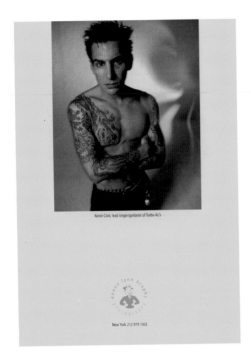

Kevin Cole, lead singer/guitarist of Turbo Ac's

New York 212 979 1302

donna lynn brophy photography

256 EAST 10th STREET • SUITE 1-D • NEW YORK NEW YORK 10009 • VOX/FAX 212 979 1302

CLIENT. Periwinkle Flowers
ART DIRECTORS. Scott Christie, Kevin Hoch
DESIGNERS. Scott Christie, Erin Boyce

ILLUSTRATOR. Emily Duvervilli
TOOLS. Photoshop, QuarkXPress, Macintosh
PAPER. Plainfield Bright White Smooth
PRINTING. McDougal & Pollard

Periwinkle Flowers

(FIT FOR A WALLET)

PERIWINKLE FLOWERS
1961 AVENUE ROAD, TORONTO, ONTARIO M5M 4A3
416.322.6985

★★★R. Seagraves identity

Elixir Design

CLIENT. Richard Seagraves
ART DIRECTOR. Jennifer Jerde
DESIGNER. Jennifer Tolo

PAPER. Crane's
PRINTING. Dickson's, Inc.

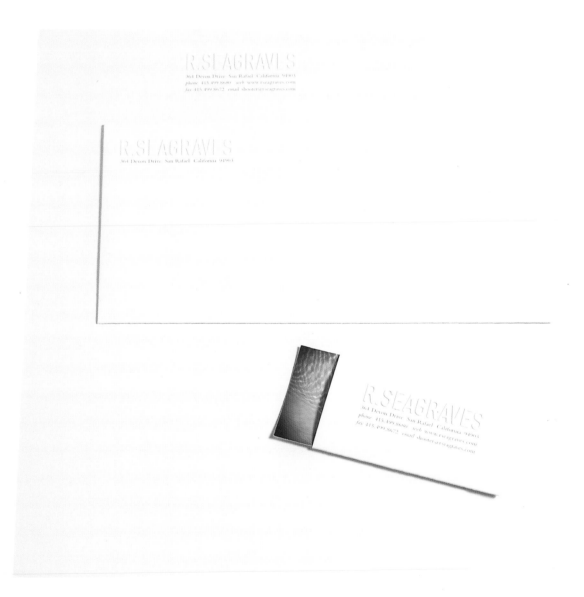

CLIENT. Chara Schreyer
ART DIRECTOR. Karin Myint
TOOL. Illustrator
PAPER. Crane's
PRINTING. Engraving and blind emboss

★★★Chara Schreyer identity
Studio 455

ORIGINS

41
1C7

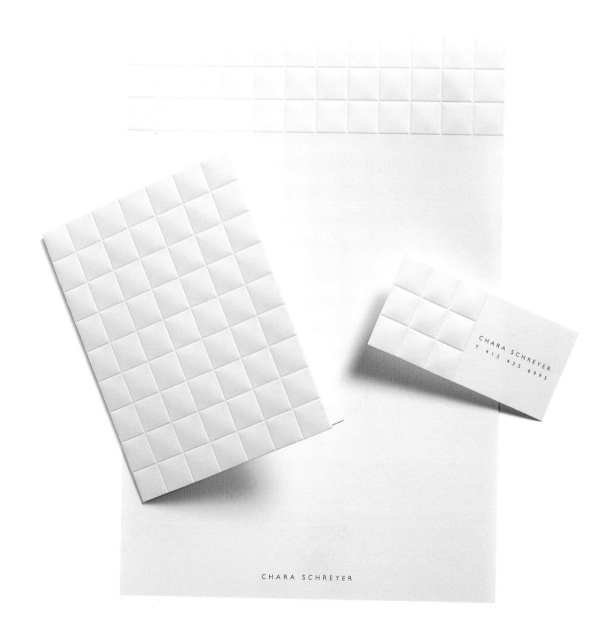

CHARA SCHREYER

CHARA SCHREYER
T 415 435 6995

FRAMING AMY

CLIENT. Amy Knapp

ART DIRECTOR/DESIGNER. Amy Knapp

TOOL. Illustrator

PAPER. Crane's Distaff Linen White Wove (ltrhd, eps); Crane's Pearl White with Beveled Silver Edges (bcard)

PRINTING. Full Circle Press

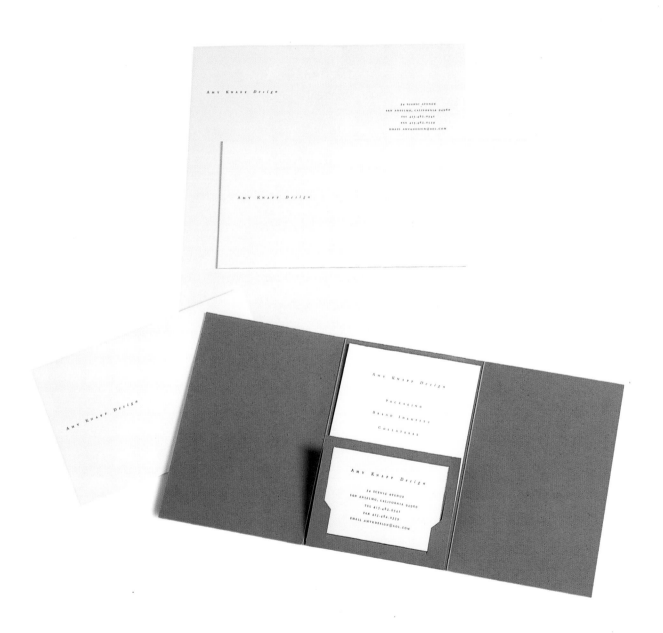

2

SCION
COLLATERAL OFFSPRING

annual reports / brochures / magazines / campaigns / direct mail / promotions

★★★November 01 film calendar mailer

Flux

CLIENT. Yerba Buena Center for the Arts
ART DIRECTOR. Steve Barretto
DESIGNERS. Vanessa Dina-Barlow, Shilla Mehrafshani

TOOLS. QuarkXPress, Macintosh
PAPER. G-Print Matte Text
PRINTING. Trade Lithography

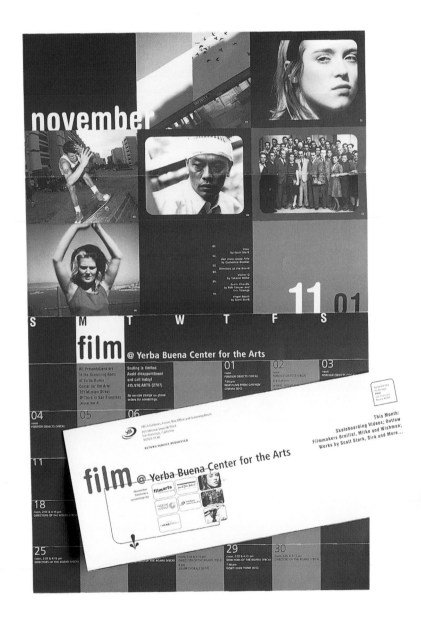

Flux

TOOLS. QuarkXPress, Macintosh
PAPER. G-Print Matte Text
PRINTING. Trade Lithography

CLIENT. Yerba Buena Center for the Arts
ART DIRECTOR. Steve Barretto
DESIGNERS. Vanessa Dina-Barlow, Shilla Mehrafshani

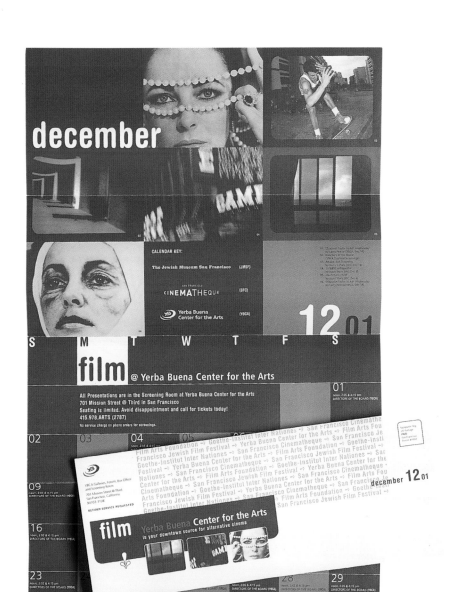

***Ballets Jazz de Montréal season brochure

KO Création

CLIENT. Ballets Jazz de Montréal
ART DIRECTOR/DESIGNER.
Denis Dulude

PHOTOGRAPHERS. Pol Baril, Nicole Rivelli, Joël Dumoulin
TOOLS. Illustrator, Photoshop, QuarkXPress, Macintosh

PAPER. Conda Supreme
PRINTING. Sheet-fed offset

lumière espace temps

La salle et la scène sont plongées dans le noir pendant quelques instants. La réalité s'estompe, il n'y a plus d'espace, de temps, de lumière. Que votre souffle. D'un seul coup, vos sens sont interpellés, la lumière vous fait découvrir des corps dans cet espace déterminé par la scène et pourtant, illimité, sans frontières, toujours renouvelé par l'imaginaire des créateurs, des artistes et des spectateurs. Pendant quelques battements de cœur, vous accompagnez les danseurs dans leur univers qui deviendra aussi le vôtre. Le temps suspendra dans votre mémoire l'arabesque d'un bras, la lumière vous associera à son rythme, et l'espace confondra en une éphémère éternité l'artiste et le spectateur.

Puis, pendant quelques instants, la scène et la salle se replongeront dans le noir, vous vous lèverez de votre fauteuil, vous émergerez de cette rencontre unique, singulière et plurielle, et vous quitterez une réalité pour en rejoindre une autre ... peut-être la vôtre.

Louis Robitaille, Directeur artistique

Texte/Text
Maryse Lapointe

Traduction/Translation
Charles Phillips

Light—Time—Open Space

For a few moments, darkness engulfs the stage and auditorium. Reality blurs, space, time and light vanish, only your breath remains. Suddenly your senses are summoned, and light reveals bodies moving in a space defined by the stage, yet unlimited, borderless, charged with the imagination of creators, artists and spectators. For a few heartbeats, you journey with the dancers into their universe, a world you now share. Time etches in your memory an arm in arabesque while light urges you to partake of its rhythm, and space merges artists and spectators in an ephemeral eternity.

Again, the stage and auditorium briefly plunge into darkness. You rise from your seat and emerge from a unique, multileveled encounter, leaving one reality, returning to another—perhaps your own.

Louis Robitaille, Artistic Director

Hua Fang Zhang → Originaire de Shanghai, Hua Fang a été formée à l'Académie de danse de Pékin. Elle danse comme soliste au Ballet central de Chine, puis le Ballet de Hong Kong comme première danseuse, et en 1989 devient membre des BJM. En 1995, toujours danseuse au sein des BJM, elle est nommée maîtresse de ballet. Elle se consacre totalement à ses responsabilités de maîtresse de ballet depuis 1998.

La maîtresse de ballet ☆ The Ballet Mistress

Hua Fang Zhang → Shanghai-born Hua Fang received her training at the Beijing Dance Academy. She performed as a soloist with the Central China Ballet, and as principal dancer with the Hong Kong Ballet. Her association with the BJM began in 1989. In 1995 while still a dancer with the BJM, she was appointed ballet mistress. Since 1998, she has concentrated exclusively on her new responsibilities.

les **BALLETS** *jazz* de Montréal

BAL
ETS
es
ALLETS

de Montréal
ESPACE **GO**

Directeur artistique
ouis **Robitaille**
Artistic Director

programme

lumière espace temps
Light—Time—Open Space

du 4 au 15 avril 2001
April 4 to 15 2001

TRENTE-HUITIÈME ASSEMBLÉE GÉNÉRALE ANNUELLE

RAPPORT ANNUEL
2000–2001
Cinémathèque québécoise

CINÉMATHÈQUE
QUÉBÉCOISE

51
1C/0
SCION

TOOLS. QuarkXPress, Macintosh
PAPER. Bytonic by Spexel/Linen Vanilla
PRINTING. Sheet-fed offset

CLIENT. Cinémathèque Québécoise
ART DIRECTOR/DESIGNER.
Annie Lachapelle

2095

/2001
RAPPORT D'ACTIVITÉS

FAITS SAILLANTS

IL A BEAUCOUP ÉTÉ QUESTION D'ARGENT A LA CINÉMATHÈQUE CETTE ANNÉE. JUSQUE SUR LA PLACE PUBLIQUE. LES FINANCES DE LA CINÉMATHÈQUE AURONT FAIT L'OBJET D'ARTICLES. D'OPINIONS ET MÊME DE PÉTITIONS.

LA CINÉMATHÈQUE QUÉBÉCOISE

MEMBRES DU CONSEIL D'ADMINISTRATION 2000-2001

Président
Jean Beaudry, réalisateur

Vice-présidents
Michel Marrez, réalisateur
Kevin Tierney, producteur, Park Ex Pictures inc.

Secrétaire
Pierre Fagues, professeur de cinéma, Cégep Ahuntsic

Trésorier
Paul Moreau, vice-président-adjoint
Les conseillers en management Mercer inc.

Administrateurs
Michel Brault, réalisateur et directeur de la photographie
Bernard Émond, réalisateur
Zynovde Lussier, avocate
René Malo, président, Cinémalo inc.
John R. Porter, directeur, Musée du Québec
Paul Racine, président et chef de la direction, Canal Évasion
Clément Richard, avocat, président,
Société de la Place des arts de Montréal
Hélène Roberge, réalisatrice et consultante en communication
Monique Simard, productrice, Productions Virage
Hubert Stéphenne, secrétaire et directeur général
Ordre des ingénieurs du Québec

MESSAGE DU PRÉSIDENT

Jean Beaudry

Photo de la page couverture : Une invention diabolique
(Vynález Zkázy) de Karel Zeman, 1958.

3e trimestre 2001

Publié par la Cinémathèque québécoise
335, boulevard De Maisonneuve Est
Montréal (Québec) Canada H2X 1K1
Téléphone : 514.842.9763
Télécopieur : 514.842.1816
Courrier électronique : info@cinematheque.qc.ca
Site web : www.cinematheque.qc.ca

Robert Daudelin
Directeur général

CLIENT. Orchard Street Market
ART DIRECTOR. Preston Wood

DESIGNERS. Preston Wood, Amy Veach
ILLUSTRATOR. Scott Greer

TOOLS. Illustrator, QuarkXPress
PAPER. Kraft
PRINTING. DuMac

★★★Orchard Street Market collateral

Love Communications

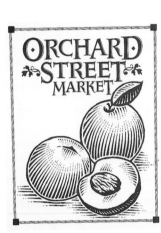

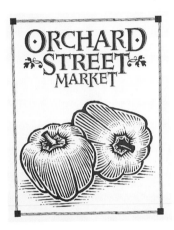

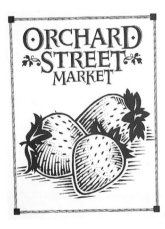

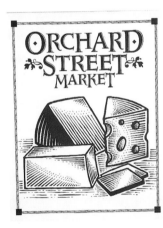

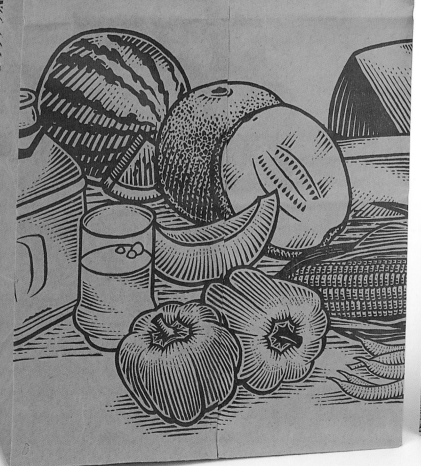

ORCHARD STREET MARKET

Where freshness is always in season.

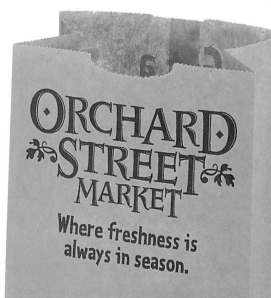

ORCHARD STREET MARKET

Where freshness is always in season.

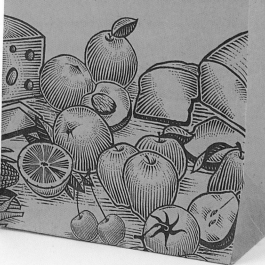

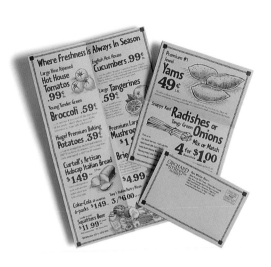

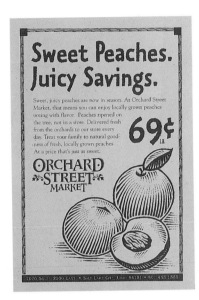

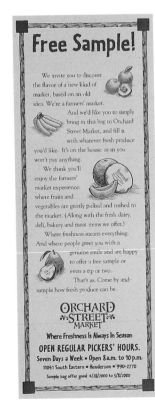

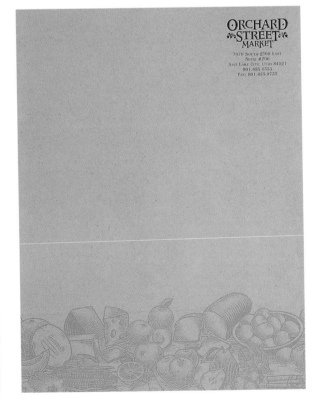

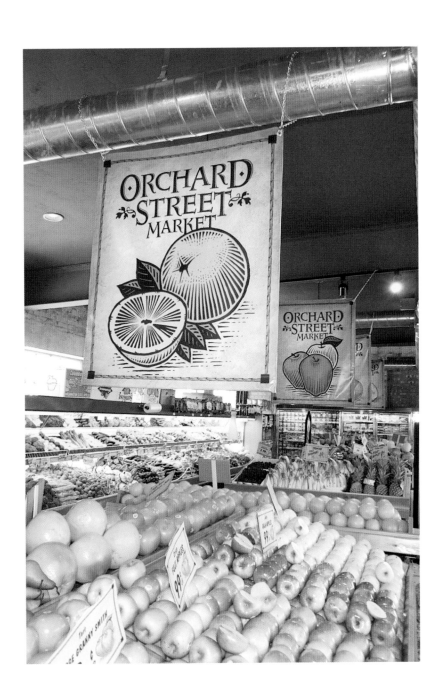

CLIENT. Target Margin Theater
ART DIRECTOR/DESIGNER. Noah Scalin
ILLUSTRATOR. David Zinn

TOOLS. QuarkXPress, Macintosh
PAPER. Domtar Weeds (text), Domtar Sandpiper (cover)
PRINTING. Offset

ARTIFACTS

This totemic artefact is one of our most exceptional finds. It appears to be a giant theic mask; a fertility god has been hypothesized.

Beaumarchais' classic contains evidence of radical revolution in the social order and bitter personal heartbreak. Yet joyous festivity in the secular sphere is also present; our team has identified numerous "jokes" as part of a so-called "comic tradition." We feel that this work can only be explained by a keen reversal of power structures amid celebration. But how are we to understand the resolution? This dig has been especially fascinating as a precursor to *Opera Mozartiana*.

ARTIFACTS

The revolutionary comedy that inspired Mozart's great opera. This classic of sexual intrigue and social power shook France in the 18th century, and it will shake New York in 2001.

The Marriage of Figaro

by Pierre Augustin Caron de Beaumarchais
Directed by David Herskovits

Emily Phillips, Scenery
Miranda Hoffman, Costumes
Josh Epstein, Lighting

At The Ohio Theater 66 Wooster Street
(see location a. on the Supplemental Information Map)

Previews start Oct. 10
Opening Oct. 17

Reservations 212-358-3657

THE DISCOVERY OF

The Operatic Era

"TARGET MARGIN THEATER
GOES TO THE OPERA"

A SEASON OF THEATRICAL ARCHÆOLOGY
AND CREATIVE SCIENCE
2001~2002

57

1 C7

SCIC

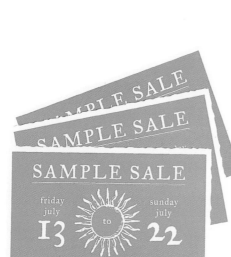

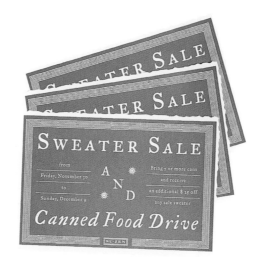

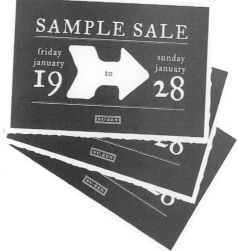

TOOLS. Freehand, Macintosh
PRINTING. Sioux Printing

CLIENT. Su-zen
ART DIRECTOR. Matteo Bologna
DESIGNERS. Andrea Brown, Matteo Bologna

58

C/G

CLIENT. Identix
ART DIRECTOR. Bill Cahan
DESIGNER. Michael Braley

TOOLS. QuarkXPress, Macintosh
PAPER. 70# Topkote Dull (cover, text)
PRINTING. Lithographix

★★★Identix 1999 Annual Report

Cahan & Associates

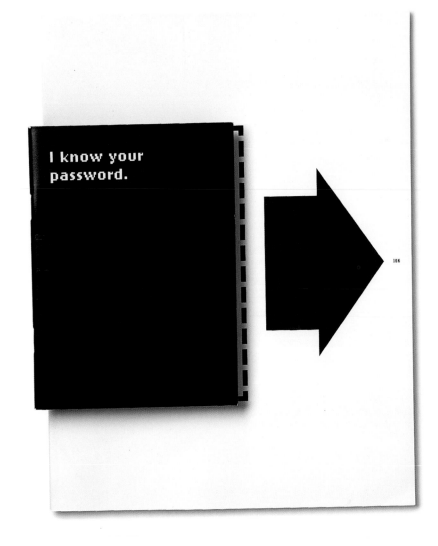

THE IDENTIX GOAL

To replace the overload of user ID cards, passwords, PINs, and other current authentication methods with something permanent and convenient that can never be forgotten, lost, stolen, forged or broken. Your fingerprint.

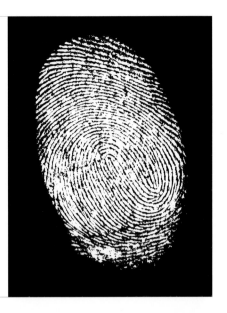

IDENTIX SCANS YOUR FINGERPRINT TO AUTHENTICATE YOU, AND ONLY YOU, FOR AUTHORIZED ACCESS AND TRANSACTIONS.

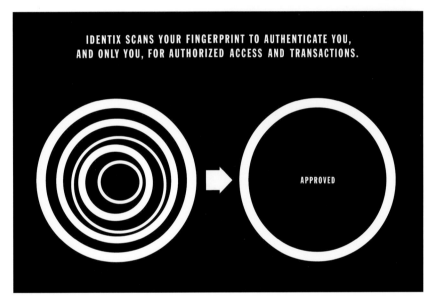

APPROVED

IDENTIX BIOMETRICS SOLUTIONS WILL BE INTEGRATED ACROSS ALL ENVIRONMENTS AND MARKETS...

E-COMMERCE

Biometrics will unlock the potential of e-commerce. Identix partners KeyTronic and Compaq provide fingerprint reader-equipped keyboards and peripheral devices, that will deliver high security for Internet transactions.

NETWORK AND SERVER ACCESS

Identix Biometrics enables the authorized user to access restricted networks, servers, databases, files and intranets with a single finger, eradicating password-related burdens on help desks.

FACILITY ACCESS

Identix physical access systems secure some of the most fortified sites, including military facilities. Identix's diverse installations range from armored cars to healthclubs.

AIRPORT SECURITY

Biometrics bolsters airport security and can deter terrorist activity. Chicago O'Hare International Airport uses Identix authentication for an array of security programs.

BANKING AND FINANCIAL SERVICES

Through fingerprint authentication, Identix solutions make online transactions, account information and other banking and financial services more convenient and more secure.

DATABASE SECURITY

Identix fingerprint authentication prevents unauthorized database access and information theft. With BioLogon™, BioShield™ and BioSafe™, Identix can protect and encrypt information and applications.

WIRELESS PHONES

Built-in fingerprint sensors will soon be an option for greater mobile phone security. Identix and Motorola have forged a partnership to build biometrics into wireless chip architecture.

CLIENT. California College of Arts and Crafts TOOLS. Illustrator, Macintosh, Agfa DuoScan

DESIGNER/PHOTOGRAPHER. Bob Aufuldish

S6095

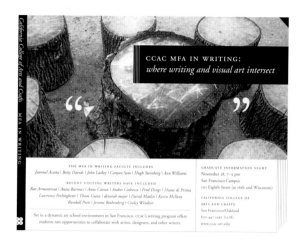

CCAC MFA IN WRITING:
where writing and visual art intersect

THE MFA IN WRITING FACULTY INCLUDES
Juvenal Acosta | Betsy Davids | John Laskey | Canyon Sam | Hugh Steinberg | Ann Williams

RECENT VISITING WRITERS HAVE INCLUDED
Rae Armantrout | Anita Barrows | Anne Carson | Andrei Codrescu | Fred Dings | Diane di Prima
Lawrence Ferlinghetti | Thom Gunn | devorah major | David Matlin | Kevin McIlvoy
Randall Potts | Jerome Rothenberg | Cooley Windsor

Set in a dynamic art school environment in San Francisco, CCAC's writing program offers
students rare opportunities to collaborate with artists, designers, and other writers.

GRADUATE INFORMATION NIGHT
November 28, 7–9 pm
San Francisco Campus
(1111 Eighth Street (at 16th and Wisconsin))

CALIFORNIA COLLEGE OF
ARTS AND CRAFTS
San Francisco/Oakland
800.447.1ART (1278)
www.ccac-art.edu

California College of Arts and Crafts MFA IN WRITING

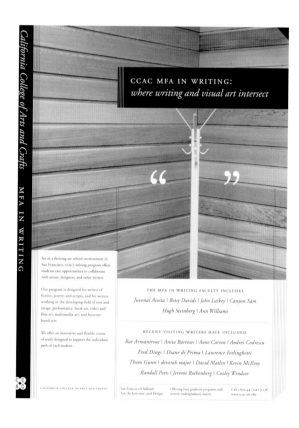

CCAC MFA IN WRITING:
where writing and visual art intersect

Set in a thriving art school environment in
San Francisco, CCAC's writing program offers
students rare opportunities to collaborate
with artists, designers, and other writers.

Our program is designed for writers of
fiction, poetry, and scripts, and for writers
working in the developing field of text and
image: performance, book art, video and
film art, multimedia art, and Internet-
based arts.

We offer an innovative and flexible course
of study designed to support the individual
path of each student.

THE MFA IN WRITING FACULTY INCLUDES
Juvenal Acosta | Betsy Davids | John Laskey | Canyon Sam
Hugh Steinberg | Ann Williams

RECENT VISITING WRITERS HAVE INCLUDED
Rae Armantrout | Anita Barrows | Anne Carson | Andrei Codrescu
Fred Dings | Diane di Prima | Lawrence Ferlinghetti
Thom Gunn | devorah major | David Matlin | Kevin McIlvoy
Randall Potts | Jerome Rothenberg | Cooley Windsor

California College of Arts and Crafts MFA IN WRITING

CALIFORNIA COLLEGE OF ARTS AND CRAFTS

San Francisco/Oakland
Art, Architecture, and Design

Offering four graduate programs and
sixteen undergraduate majors

Call 1.800.447.1ART (1278)
www.ccac-art.edu

★★★Frakcija magazine

Igor Masnjak Design

CLIENT. Frakcija, Performing Arts Magazine
ART DIRECTOR/DESIGNER/ILLUSTRATOR. Igor Masnjak
TOOLS. QuarkXPress, Photoshop, Freehand, Macintosh
PAPER. 135g/m² Magnomatt
PRINTING. Offset litho

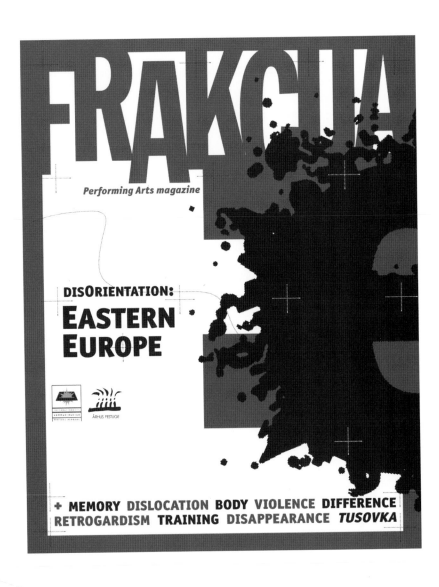

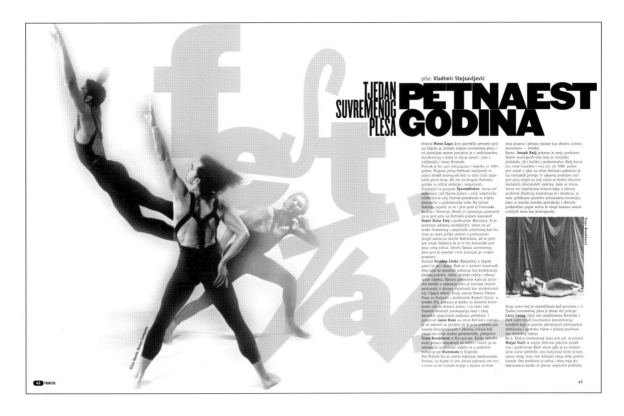

piše: **Vladimir Stojsavljević**

TJEDAN SUVREMENOG PLESA
PETNAEST GODINA

Festival **Mirne Žagar** kroz proteklih petnaest godina bilježio je istinske mijene suvremenog plesa i od najznačajnije umotne preostao je u međunarodnu manifestaciju o kojoj se danas govori i piše s osobljnošću i izvan Hrvatske.

Početak je bio pun entuzijazma i dogodio se 1984. godine. Program prvog festivala sačinjavali su radovi mladih koreografa koji su tada činili zagrebački plesni krug. Ali već na drugom festivalu postale su očiti ambicije i mogućnosti.

Stavljajući na program **Sparembkov**, danas već legendarni, rad *Pjesme (ljubavi i smrti)* umjetnička voditeljica je svoj Festival pomaknula iz svijeta alternative u profesionalne vode. Na trećem Festivalu pojavili su se i prvi gosti iz Francuske, Austrije i Slovenije. Možda je najvažnije spomenuti da se prvi puta na Festivalu pojavio koreograf **Damir Zlatar Frey** s predstavom *Metastaze*. To je predstava urbanog senzibiliteta, istina ne još onako formiranog i umjetnički uobličenog kao što ćemo ga imati prilike gledati u predstavama drugih autora na idućim festivalima, ali za povijest ostaje zanjenira da je to bio festivalski prvijenac ovog autora. Četvrti Tjedan suvremenog plesa prvi je uspešan i vrlo značajan po svojem programu.

Dolazak **Susanne Linke** (Njemačka) u Zagreb pamti se još i danas. Radi se o autorici istančanih ideja koje na pozornici pokazuje kao kombinaciju plesnog pokreta, tišine, mimske radnje i odnosa upram objekta. Njezino poplavlenje kade po pozornici Gavelle u najmanju ruku je razvojek slomilo predrasudu o plesnoj umjetnosti kao visokoformalnoj i lijepoj zabavi. Drugi nastup Damira Zlatara Freya na Festivalu s predstavom *Rospeh Glorije*, u izvedbi ZPA, pokazao je koliko su elementi koreodrame uzti za domaću scenu, i ne samo radi Freyevih intimnih preokupacija nego i zbog plesačih mogućnosti sudionica predstave. I prijestnost **Janne Knez** na ovom Festivalu svakako je od vaznosti za povijest jer je java pokazala preispotanje konceptualnosti i plesnog izričaja koji danas ima svoje plesne predstavnike, primjerice **Truns Bronkhont** iz Nizozemske. Koliko tehnički može plesu odnokoniti od baleta i vinuti ga do neslurenih izražajnosti vidjeti se u predstavi kultne grupe *Diversions* iz Engleske.

Peti Festival bio je zasvim legitiman međunarodni Festival, na kojem su dva autora pokazala sala ovo o čemu su već nastale knjige u kojima se drum-

okog glumca i plesača opisuje kao idealni sintem imenovanu — izvođač.

Naime, **Joseph Nadj** pokazao je svoju predstavu *Sedam nocovopovih koža* koja je oduševila gledalište, ali i kritiku i profesionalce. Nadj danas na svoje kazalište i svoj stil, od 1986. godine prvi susret s njim na ovom Festivalu pokrenuo je niz teorijskih pitanja. U njegovoj predstavi smo prvi puta vidjeli na koji način se koristi iskustvo borilačkih istočnjačkih vještina, kako se stvara danas vrl izgaličzna dramaturgija i plesnoj predstavi (funkcija dramaturga je i dandanas za nakse cjelokupno glumište preusranjena inovacija), kako se poetire scenska apstrakcija s običnim predmetima poput stolca te uloga bumeza unutar ozbiljnih tema kao kontrapunkt.

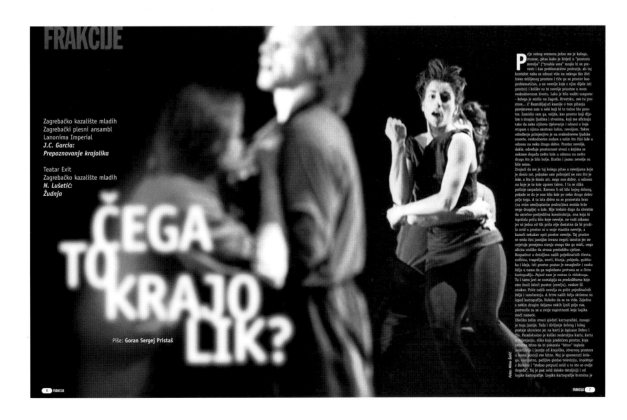

Drugi autor koji je nezaobilazan kad govorimo o 5. Tjednu suvremenog plesa i danas već pokojni **Larry Leong**, čijim smo predstavama *Eventides* i *Dark Light* svjeti fascinantnu koncentraciju izvođača koja se je poritre zahvaljujući istočnjačkim vještinama i uspršelni tišine u plesnoj predstavi kao dramskoj nabijen.

Na 6. Tjednu suvremenog plesa prvi put se pojavio **Matjaž Farič** sa svojim internim plesnim projektom i predstavom *Kikeli alarm* gdje je na nevjerojatan način predvidio ono budućnost bivše države, njenim ustroj i nego dotivjeli svega dvije godine kasnije. Ova predstava je važna i zbog toga što dokumentira koliko se plesna umjetnost približila

Zagrebačko kazalište mladih
Zagrebački plesni ansambl
Lanonima Imperial
J.C. Garcia:
Prepoznavanje krajolika

Teatar Exit
Zagrebačko kazalište mladih
N. Lušetić:
Žudnja

ČEGA TO KRAJOLIK?

Piše: **Goran Sergej Pristaš**

Foto: Nina Šolić

Prije nekog vremena jedan me je kolega, stranac, pitao kako je živjeti u "prostoru nevolje" ("trouble area" moglo bi se prevesti i kao problematično područje, ali taj kontekst neka se odnosi više na nekoga tko živi izvan mišljenog prostora i tiče ga se prostor kao problematičan, a ne nevolje koje s njim dijele isti prostor i koliko su te nevolje prisutne u mom svakodnevnom životu. Lako je bilo voditi razgovor - kolega je mislio na Zagreb, Hrvatsku, ove tu prostore…? Razmišljajući kasnije o tom pitanju provjeravao sam u sebi koji bi to točno bio prostor. Zamislio sam ga, valjda, kao prostor koji dijelim s drugim ljudima i stvarima, koji me aficiraju tako da neka njihova djelovanja i odnosi u koje stupam s njima smatram lošim, nevoljom. Takvu određenje primjenjivo je na svakodnevne ljudske susrete, svakodnevne sudare s onim što čini loše u odnosu na neko drugo dobro. Prostor nevolje, dakle, određuje prostornost stvari s kojima se nekome događa nešto loše u odnosu na nešto drugo što je bilo bolje. Kratko i jasno: nevolje su bile tazne.

Znajući da je taj kolega pitao o nevoljama koje je donio rat, pokušao sam pohrajati ne ono što je loše, a što je donio zrt, nego ono dobro. u odnosu na koje je to koše upravo takvo. I tu se slika počinje razpadati. Krenem li od bilo kojeg dobrog, pokaže se da je ono bilo loše po zeko drugo dobro prije toga. A ta lata dobra su se prometala bržo (na ovim zemljopisnim područjima možda bržle nego drugdje) u loše. Nije trebalo dugo da shvatim da uzročno-posljedične konstrukcija, ona koja bi ispričala priču koje nevolje, ne vodi nikamo jer ni jedna od tih priča nije dostatna da bi pružila uvid u prostor ni u moje vlastite nevolje, a kamoli nekakav opći prostor nevolje. Taj prostor se onda čini jasnijim izvana nepoli iznutra jer ne uvjetuje promjenu stanja onoga tko ga misli, nego afícira utoliko da stvara predodžbu cjeline. Raspadnut u detaljina nadih pojedinačnih života, sudbina, tragedija, smrti, klanja, pobjeda, gubitaka i ideja, isti prostor postao je nesagledivo i svaka želja o nama da ga sagledamo pretvara se u čistu kartografiju. Pojeod nam je nestao iz vidokruga.

Tu i tamo javi se nostalgija za predodžbama koje smo imali želeći prostor (zemlju), ovakav ili onakav. Priče naših nevolja su priče pojedinačnih želja i razočaranja. A žrtve naših želja skrivene su ispod kartografije. Duboko da se ne vide. Zajedno s nekim drugim željama nekih ljudi prije nas, pretvorile su se u svoje suprotnosti koje logika moći nemače.

Ukoliko želim stvari gledati kartografski, mnogo je toga jasnije. Tada i divljanje dobrog i loseg postaje ukroćeno jer na karti je ispisano Dobro i Zlo. Paradoksalno je koliko nedetaljna karta, a mijenjanju, slika koja predočava prostor, koja izražava bitno da ni je pokazala "bitno" izgleda nevjerljivo i jasnije od krajolika, stvarnog prostora u kome postoji sve bitno. Moj je spomenuti kolega, vjerojatno, pažljivo gledao televiziju, invjeltaje o Balkanu i "stekao potpuni uvid u to što se ovdje događa". Taj je pak uvid daleko detaljniji i od logike kartografije. Logika kartografije brutalna je

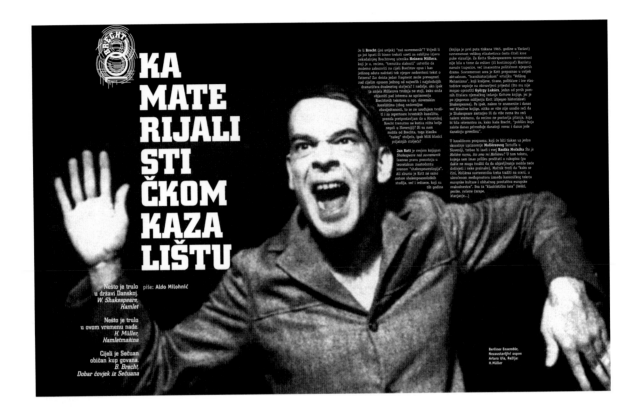

KA MATE RIJALI STI ČKOM KAZA LIŠTU

piše: Aldo Milohnić

Nešto je trulo
u državi Danskoj.
*W. Shakespeare,
Hamlet*

Nešto je trulo
u ovom vremenu nade.
*H. Müller,
Hamletmašina*

Cijeli je Sečuan
običan kup govana.
*B. Brecht,
Dobar čovjek iz Sečuana*

Berliner Ensemble,
Nezaustavljivi uspon
Artura Uia, Režija:
H. Müller

Metafora javnosti

piše: **Suzana Marjanić**
snimio: **Boris Cvjetanović**

Josette Féral manipulaciju kojom performans podvrgava tijelo izvođača (performera) određuje *kameleonskim tijelom* (1996:208), i iz navedenoga ontologema tijela postavlja dodirnost između performansa i smrti: "Performans je kao fenomen djelovanja kroz želju za smrću", a polazi od iskustva "tijela koje se ranjava, sakati i reže (...), tijela koje u potpunosti prihvaća *lesionizam*" (1996:209). I dok je, primjerice, **Ron Athey** na Eurokazu 1997. godine predstavom *Deliverance*[1] objavio vlastito tijelo "oljušteno" do srži, u kojemu je upisan tekst života suočavanja s vlastitom Smrću, a u predstavi *Incorruptible Flesh* (**Lawrence Steger** & Ron Athey) tijelo arhaične formule hermetičkog "ženomuža" (ženi sličan svetac) – muško spolovilo tehnikom "klamanja"-*piercing* metamorfozirano je u usjeklinu ženskoga spolovila, postavljajući u dodirnost *body art*[2] s formama ritualne tanatomorfoze i pročišćenja; *Tjedan performansa* pod nazivom *Javno tijelo*, u organizaciji zagrebačka Soros centra za suvremenu umjetnost (SCCA-Zagreb) i nezavisnog umjetničkog projekta *Doma-A casa-At Home*, koji je održan u Zagrebu 14-18. listopada 1997. godine, svojom naslovnom sintagmom eksteriorizirao je privatno tijelo u *metaforu javnosti*.

Tjedan performansa "Javno tijelo"; Zagreb, 14.-18. 10. 1997.

Kameleonsko tijelo i tijelo kao otisak sjećanja (autobiografsko tijelo)

Razgovor s **Tomislavom Gotovcem** prigodom njegova performansa

Prilagođavanje objektima na Trgu maršala Tita (Trg maršala Tita, volim Te!)

[Kao uvodno pitanje mogu postaviti pitanje kada su započela tvoja performans istraživanja.]

T. Gotovac: ...

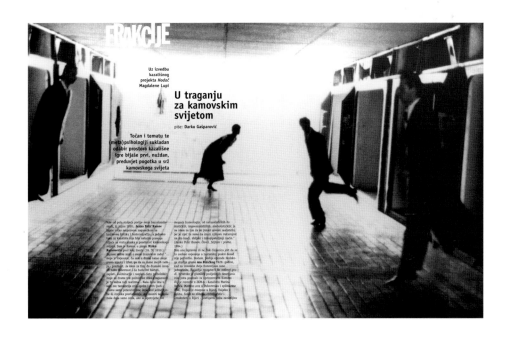

Uz izvedbu kazališnog projekta *Hodač* Magdalene Lupi

U traganju za kamovskim svijetom

piše: **Darko Gašparović**

Točan i tematu te (meta)psihologiji sukladan odabir prostora kazališne igre bijaše prvi, nužan, preduvjet pogotka u srž kamovskoga svijeta

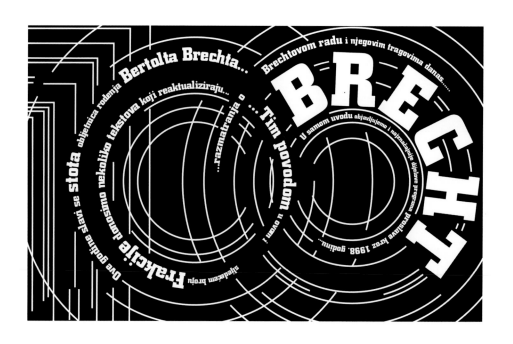

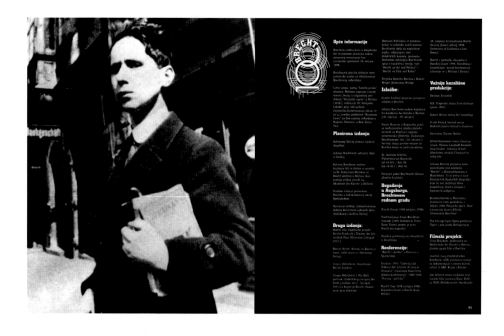

Ivica Buljan
Razgovarala Ivana Sajko

Bojana Kunst

Of Body Natural and Artificial

In this essay I would like to go back a while, to the beginning of the century, and speak of one of the main characteristics of the then current utopias of the body, which have profoundly affected the representation of the body in the century now drawing to its close. The paradoxes, hidden in the utopias of the natural body, to this day continue to haunt and shape the fugitive margin of the body; the body, having already been through all imaginable forms of restructuring, deforming, deconstruction, as well as the innumerable ways of reading, appears now only as a scandal, always ready to point to the flesh (we can call it pleasure too), always creeping in through the back door, always on that ever thinning line separating body from machine, at the moment, in the words of Donna Haraway, when "machines become disturbingly alive". A notion, dating from the early 20th century, seems to me to be typical of the thinking about utopias inscribed in the body, which also guard and dictate the ways of its representation; it is the hopeless search for the natural body, that after all determines the beginnings of modern dance also, as well as certain important shifts in theatrical representation. Movement is the representational strategy which has become the be-all and end-all of that search. Movement of any kind: "This new irrational 'something,' that comes from the flowing life flow, is the new corporeality... body culture, gymnastics, dance, cult dance, spatial dance, new corporeality, new bodily sensation, body-soul, new callisthenics, movement, rhythmics with its innumerable attributes... These are the signs of the new."[1] Movement in the basic method of naturalizing and shaping of the body is the theme treated by some of the most eminent apologists of the return to the natural body, among them the most active and representative being the Life Before Movement [Lebensreformierung] or Lebensreform-Bewegung], which has explicitly combined the populist tendency for life and social reform of the masses with the aesthetic reform, and thus in the best tradition of the early 20th century movements, which have mostly sought to unite art and life, brought about the new concept of the body. Numerous pioneers of modern dance e.g. Isadora Duncan, Ruth St. Denis, Ted Shawn, Mary Wigman, Rudolf Laban, who emphasized the return to the natural body, i.e. its autonomous expressivity, as the basic method of liberating modern dance from the traditional discourses (above all, the figural rhetoric of the ballet), were directly or indirectly involved with these movements. Aesthetic autonomy of the body has thus through Lebensreformierung and through modern dance been developed above all by

[1] Wolfgang Graeser: Körperseie, München, 1921.

means of methodical exploration of the kinetics, i.e. the rhythmical quality, of the body, and through the real emancipational aesthetic theory of movement expression, that should bring man and his body back to their original being.

When we inspect closely the character of the natural body in the statements of its apologists at the beginning of the 20th century, we should by no means be mislead by their enthusiasm, for it is easy to dismiss them at first sight as being only an expression of the resistance to industrialization and the modern way of life. Although this resistance can be understood as the source of the important beginning-of-the-century movements, which somehow start to intimate the problematic co-existence of man and machine in the modern urban way of life, it is precisely in their techniques (that range from the search for rhythm and new kinetic structures, to such absurdities as nude skiing), that the fugitive, dynamic, energetic and kinetic body, that has no fixed skin boundary, is reflected, the body capable of endless kinetic flow, repetition, energetic efficiency, swaying, kinetic transmission and mediation: the body, then, the kinetic characteristics of which mirror the characteristics of modern motors, i.e. technological structures, confronting at the beginning of the century the human body with new forms of representation (the invisible dynamics of electricity, audio-visual machines, the problem of speed, etc.). Modern sports, dance, gymnastics, rhythmics, swimming, movement flow (occasionally accompanied by the use of other body codes), give back to the body some of its natural characteristics, simultaneously blending it with the actions of machines, training it to the new dynamic rhythm of automatised efficiency. The concept of natural body at the beginning of the century is thus not some new romantic concept of longing for nature, i.e. the natural life of the body, as it might at first seem; that body is in fact the body of hygienic minimum, obviously healthy and fertile body, the transformed body that has no problems in inhabiting some machine habitat of Le Corbusier's, in its essence already transformed and connected to the artificial. A blasphemous thought easily comes to mind, revealing the utopia constantly being disclosed in the case of the natural body: the image of body fullness, the techniques of representation of which are often caught in the image of the artificial, the automaton, the machine (this goes especially for the performing arts). The image, where the in fact impossible body - in this instance, the body of hygienic minimum, the body stripped of everything, presented as the sovereignty of kinetic flow only - is linked to the image of the machine, of artificial structure, hides in itself also the end of one of the most important utopias of the

Enlightenment project, that at the beginning of the 20th century completely blends the natural and the artificial. No wonder, than, it was precisely the artificial body that in the thirties became the central metaphor which witnesses the wonder of life (of this I will say more in the conclusion).

What consequences does this have for the self-representation of the body? The emergence of modern dance is of special interest here, for a new artistic form was being born, the form which seems to reflect in its beginnings certain basic relations between the natural and the artificial. A fundamental insight seems to be the origin of modern dance: expressive autonomy, i.e. kinetic autonomy, of the body, which represents the body itself as an autonomous aesthetic field, subject only to its own epidermal openness and its own kinetic flow. Dance thus, in the words of the poet Valéry, becomes "a way of inner life, which satisfies that psychological notion of new life, where physiology is dominant."[2] Although in almost every programmatic statement made by the reformers and originators of modern dance the tendency of return to the natural body is being emphasised,[3] sometimes also connected to the original ritual body, it is precisely in this tendency that we find the new physiology inscribed, the new body engineering, shaped in the collective co-existence of body and machine as the dynamic motor and kinetic energy structure, offering also the ideal of autonomy and power. The most important metaphors that we find in the artistic concepts in the beginnings of modern dance (and in everyday life too), like the movement flow (the key word when the expression of the body is to be designated), rhythmics, energy, rhythmic flow, thrusts, pulsations, swaying, etc. are, although understood as the basic means of making the body natural and free, in fact, characteristics of the body as dynamic motor. The union of body and machine in everyday urban way of life thus strongly influences the modern dance image of the body as pulsating movement flow. Every return to the origin of the body (in dance as well) is therefore paradoxically linked to it artificial/impossible equivalent.

It would be wrong to understand the above-mentioned as a process that, despite certain illusions of returning to its origins, deprives the body of its autonomy and subjects it to the artificial. It is important that, through revealing some links between the natural and the artificial, we can follow certain characteristics of new bodily representation. All the more, it seems, because this interplay of body and machine (i.e. the characteristics of new technology), gives back its

[2] Paul Valéry: 'Philosophie de la danse' in: Œuvres I, Éditions Gallimard, 1957, p. 1388.

[3] Isadora Duncan: The Dancer of the Future. Also: "For hours I would stand quite still, my two hands folded between my breasts, covering the solar plexus (...) I was resting, and finally discovered, the central spring of all movement." Isadora Duncan: My Life, London: Victor Gollancz Ltd., 1928, p. 75.

autonomy to the body, not only establishing it as a new autonomous aesthetic form with a specific system of signs and a separate structure, but turning its autonomous expressivity into the fundamental system of meaning in modern dance, the fugitive kinetics into its structural network, a form no longer mimetic but dynamic and subject to its own laws. And this autonomy is specific, determined by the fugitive quality and dynamics of the artificial structure, the comprehensibility of the sign no longer being its concern. Herein lies the essential paradox of movement as the basic technique of making the body natural: it draws attention to the body, although it is losing it ever more, the moving body becoming a tense structural network, a minimalist play of parts, shadows, traces. The meaning, therefore, vanishes, and in its stead a "structure" is revealed, which later also becomes the essential modernist paragon and model of the existence of the body.

The French philosopher Michel Bernard claims that one of the consequences of the new physicality of the body is precisely the precedence of energy over meaning, which results in the breakdown of communication, i.e. in the inception becoming more difficult.[4] Instead of a transparent gestural body sign, we have in front of us a pulsating energy field: the expressivity of the body equals the epidermal energy flow. Thus the very structural and representational status of the body is changed, the new kinetic body refuses to be subjected to the imperialism of the transparent sign and sovereign intention of the body, which is both the subject and the object, which represents and exposes itself. The moving body lives through the pulsation and circulation of its energies, establishes autonomous energy language, the characteristics of which are incessant irreversible, velocity, discontinuity, dissemination, etc. The new kinetics can thus, according to Bernard, be understood as "the art of loss" (l'art de la dépense): the art of loss is the sphere of the spectator's comprehension, for this following of the shadows of loss becomes the essential principle of the spectator's seeing, i.e. interpretation (embodied in contemporary performance art), but also the art of loss of the body itself. This is no longer the mimetic body, but the body that

[4] Michel Bernard: 'Les nouveaux codes de la danse contemporaine,' in: Le Corps et ses fictions dans l'art de la danse et du théâtre', aux Editions Payot Lausanne, 1990, pp. 68-76.

★★★Autobiography self-promo booklet

A Day in May Design

CLIENT. Eve Billig

ART DIRECTOR/DESIGNER/ILLUSTRATOR. Eve Billig

TOOLS. QuarkXPress, Illustrator

PAPER. Classic Crest Duplex (cover);
Synergy Line, Variety (chapters)

PRINTING. Full Circle Press

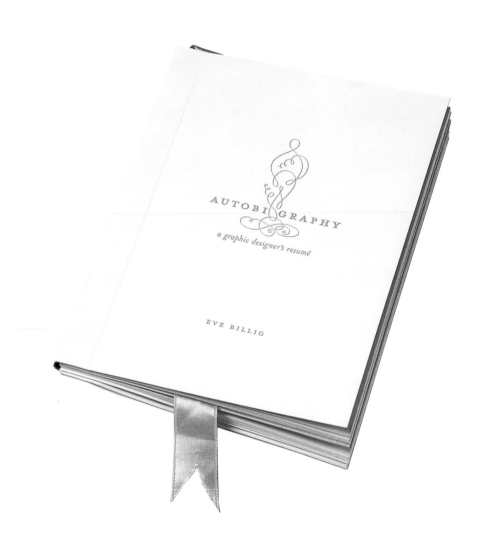

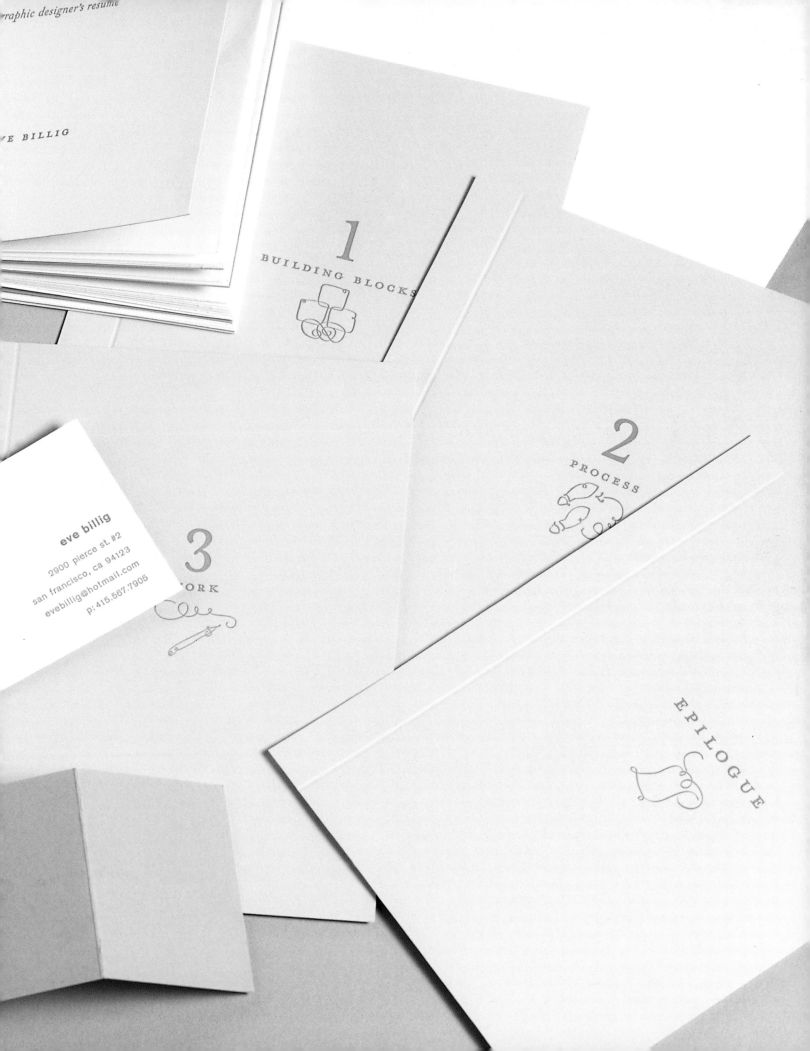

raphic designer's resume

e billig

1
BUILDING BLOCKS

2
PROCESS

3
ORK

EPILOGUE

eve billig
2900 pierce st. #2
san francisco, ca 94123
evebillig@hotmail.com
p: 415.567.7905

★★★"Peace Out" holiday greeting

Public

CLIENT. Public
ART DIRECTOR. Todd Foreman
DESIGNER. Tessa Lee

TOOLS. Illustrator, Macintosh
PAPER. French Frostone
PRINTING. San Francisco Center for the Book (by Public)

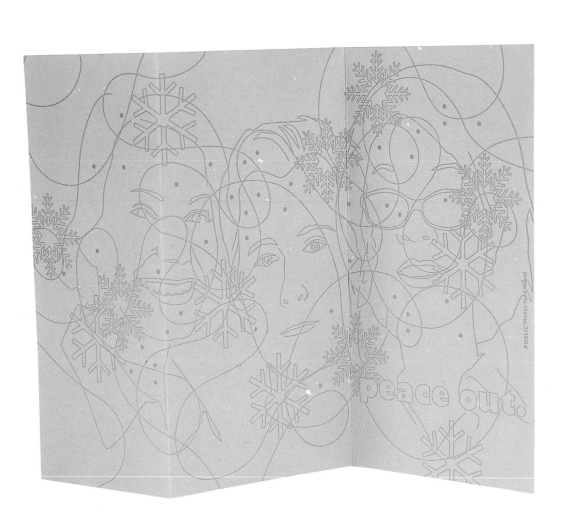

71

1 C /

SCIO

CLIENT. Industry Films
ART DIRECTOR. Vanessa Eckstein
DESIGNER. Stephanie Yung

TOOLS. Illustrator, Macintosh
PAPER. Strathmore
PRINTING. C.J. Graphics

IT'S ABOUT A CURE. ON YOUR BEHALF WE MADE A DONATION TO THE AIDS COMMITTEE OF TORONTO AND TO THE BREAST CANCER SOCIETY OF CANADA. HAPPY HOLIDAYS + OUR BEST WISHES FOR 2001. FROM ALL OF US AT INDUSTRY FILMS.

CLIENT. The Partners Film Company
ART DIRECTOR. Vanessa Eckstein
DESIGNERS. Vanessa Eckstein, Frances Chen

TOOLS. Illustrator, Macintosh
PRINTING. C.J. Graphics

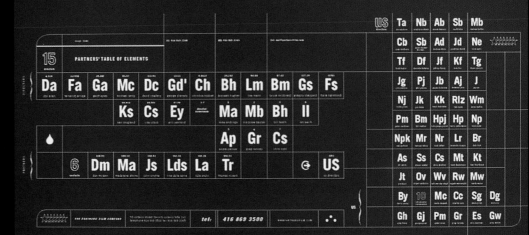

SCION

CLIENT. Gillespie Design
ART DIRECTOR. Maureen Gillespie

DESIGNER. Liz Schenker
PRINTING. Offset, Lightning Copy

★★★Gillespie Design holiday card

Gillespie Design, Inc.

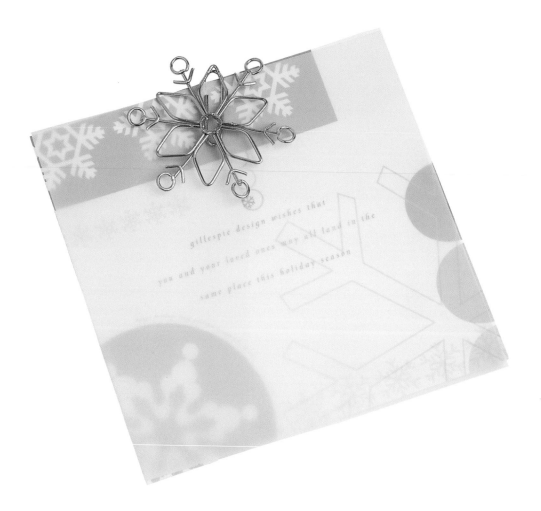

gillespie design wishes that

you and your loved ones may all land in the

same place this holiday season

75

1 C /

SCION

TOOLS. Illustrator, Photostop, Macintosh
PRINTING. Sheet-fed offset

CLIENT. KO Création
ART DIRECTOR/DESIGNER. Denis Dulude

Biennale internationale de design graphique du Québec • deuxième édition
Quebec's International Graphic Design **Biennial** • second édition
Internationale graphische **vormgevingsbiennale** Québec • tweede aflevering

INVLOEDS

DENIS DULUDE 9 H AM
19·10·00

ZONE::: 18·22

octobre / october / oktober

2000 Montréal Canada Pays-Bas Netherlands Nederland

"HOLLANDAIS, E adj. et n. De Hollande
❦ Sauce hollandaise, à base de jaunes d'œufs
et de beurre, additionnée de jus de citron.

SOURCE : LE PETIT LAROUSSE ILLUSTRÉ 1997

MERCI À CAROLE ET BERNARD DE M'AVOIR SI GENTIMENT INVITÉ À CETTE DEUXIÈME ÉDITION DE LA BIENNALE. J'EN SUIS TRÈS HONORÉ.
MERCI À PHILIPPE ET MICHEL DE COMPLÈTEMENT LITHO POUR L'IMPRESSION DE CETTE AFFICHE.

CLIENT. Mo'nia

ART DIRECTOR/DESIGNER/ ILLUSTRATOR. Mo'nia

TOOLS. Photoshop, Freehand, Macintosh

★★★Mo'nia stamps

Mo'nia

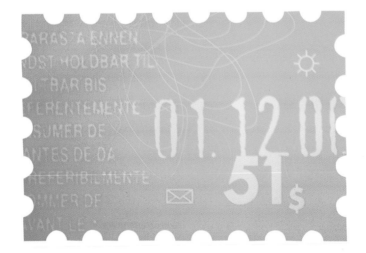

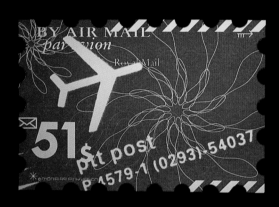

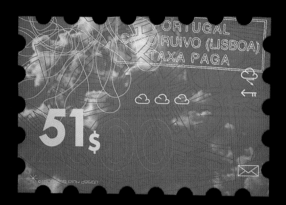

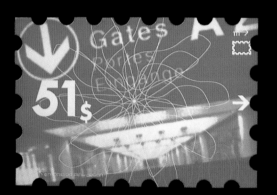

★★★Anni Kuan Design self-promotion

Sagmeister, Inc.

CLIENT. Anni Kuan Design
ART DIRECTOR. Stefan Sagmeister
DESIGNER/ILLUSTRATOR. Ella Smolarz

TOOLS. Illustrator, Photoshop
PAPER. Newsprint
PRINTING. Newsprint

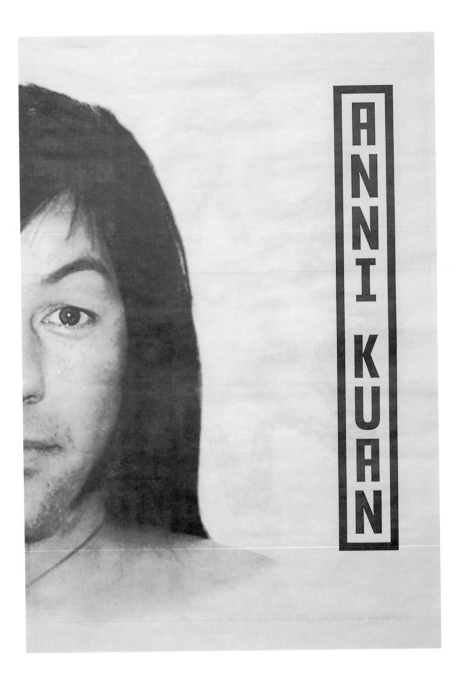

A LINE SKIRT IN COCOA SILK TWEED W/ ULTRA SUEDE TRIM

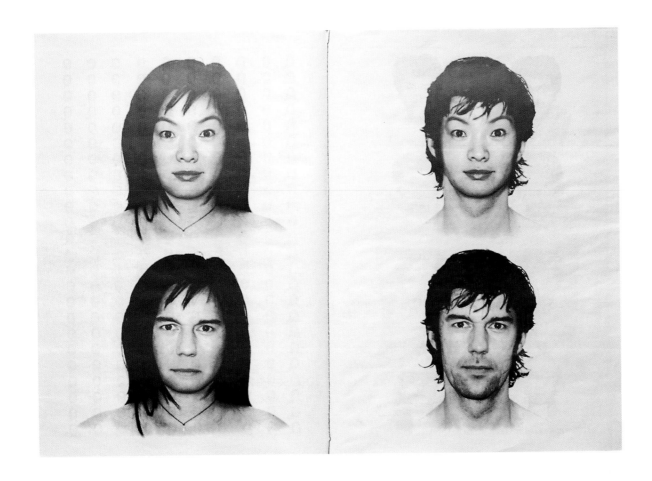

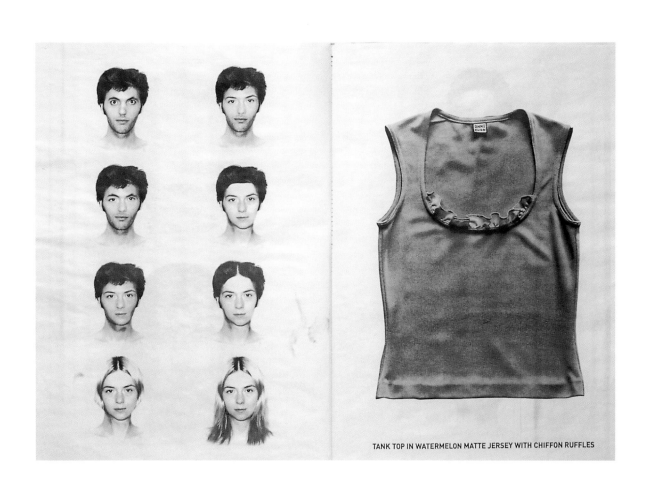

TANK TOP IN WATERMELON MATTE JERSEY WITH CHIFFON RUFFLES

CLIENT. Anni Kuan Design
ART DIRECTOR. Stefan Sagmeister
DESIGNERS. Stefan Sagmeister, Hjalti Karlsson

TOOLS. Illustrator, Photoshop
PAPER. Newsprint
PRINTING. Newsprint

PHOTOGRAPH OF
NEW YORK CITY
SKYLINE REFLECTED
IN RAIN PUDDLE.

PHOTOGRAPH OF
ANNI KUAN
EMBROIDERED LABEL,
THREADS SHOWING.

SUPER SHARP PHOTOGRAPH OF LUMPS OF BLACK COAL, ARRANGED TO TAKE THE SAME OUTLINE SHAPE AS DARK HAIRED MODEL ON OPPOSITE PAGE.

PHOTOGRAPH OF DARK HAIRED MODEL (WITH LIGHT MUSTACHE) IN ANNI KUAN BLACK RAYON MATTE JERSEY FLOOR-LENGTH DRESS WITH A LOW V-NECK FRONT AND BELL SLEEVES WITH BLACK FUR TRIM.

PHOTOGRAPH OF RED STRING, LYING LOOSELY AND RESEMBLING BORED BLOND WOMAN.

PHOTOGRAPH OF BORED BLOND WOMAN, ONE BREAST SHOWING, CARRYING NAKED BABY, IN A LIPSTICK RED FUZZY ANGORA LOW-CUT BALLERINA TOP OVER A MULTI-COLORED COLLAGED SILK CHARMEUSE BIAS-CUT LONG SKIRT.

PHOTO OF RECLINING RED HAIRED GIRL WEARING LARGE SQUARE SUNGLASSES AND LICKING CHERRY LOLLIPOP IN BLOOD ORANGE DOUBLEKNIT TEE WITH MOHAIR CORD TRIM WORN OVER BROWN STRETCH WOOL CROPPED PANTS WITH SHAGGY CHENILLE CUFFS, ACCESSORIZED WITH A BERRY MOHAIR TOTE BAG.

PHOTOGRAPHIC IMAGE OF 3 BRICKS GROUPED TO RESEMBLE CONTOUR OF RED HAIRED GIRL.

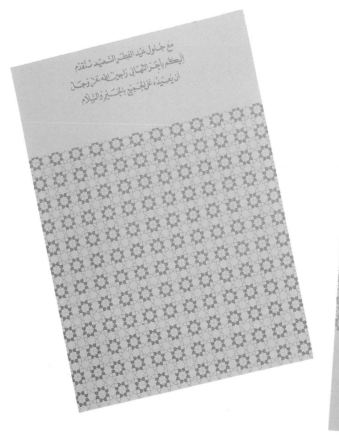

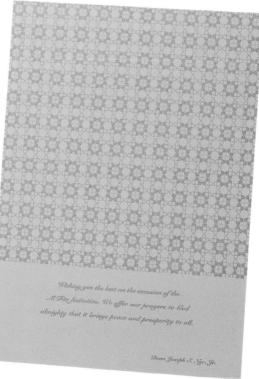

★★★Al Fitr holiday greeting

Nassar Design

CLIENT. Harvard School of Government
ART DIRECTOR/DESIGNER. Nelida Nassar

TOOLS. QuarkXPress, Photoshop
PAPER. Champion Benefit 100#C
PRINTING. Offset

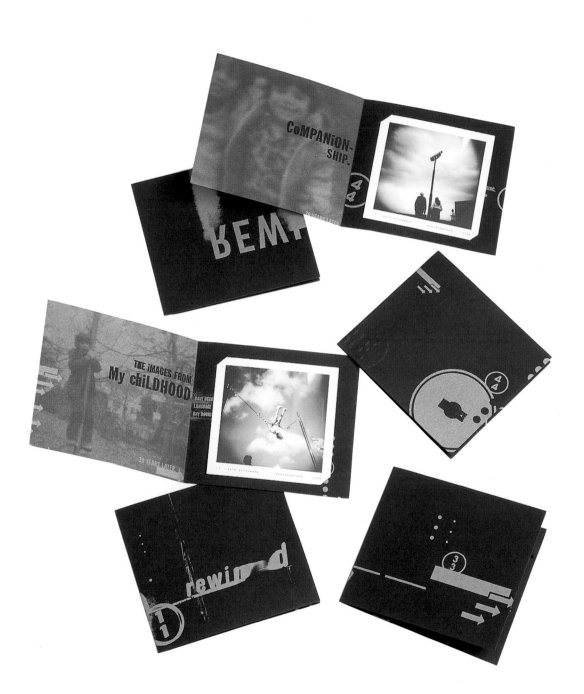

CLIENT. Seth Affoumado
ART DIRECTOR/DESIGNER. Tom Sieu

TOOLS. Photoshop, QuarkXPress, Macintosh, photocopy
PAPER. Black Uncoated Recycled Stock
PRINTING. Offset

3

MACRO

DETAILS AT A DISTANCE

posters / installations

★★★CCAC posters

CLIENT. California College of Arts & Crafts
ART DIRECTOR. Jennifer Morla

DESIGNERS: Sara Schneider, Jennifer Morla
TOOLS: QuarkXPress, Illustrator,
Photoshop, Macintosh

PAPER. Newsprint
PRINTING. Offset, black ink

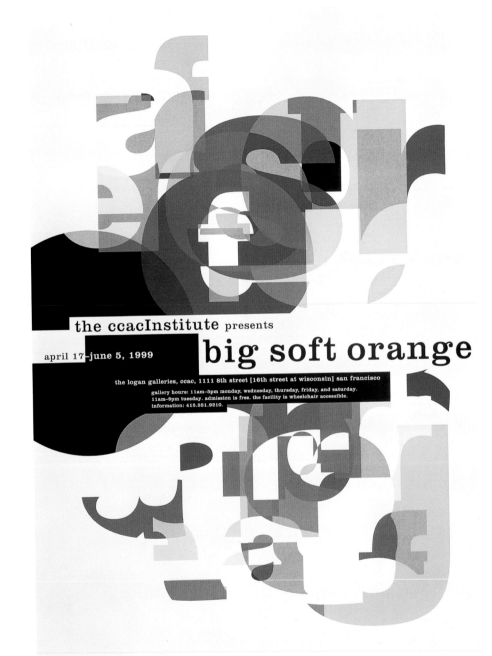

the ccacInstitute presents

april 17–june 5, 1999

big soft orange

the logan galleries, ccac, 1111 8th street [16th street at wisconsin] san francisco

gallery hours: 11am–5pm monday, wednesday, thursday, friday, and saturday.
11am–9pm tuesday. admission is free. the facility is wheelchair accessible.
information: 415.551.9210.

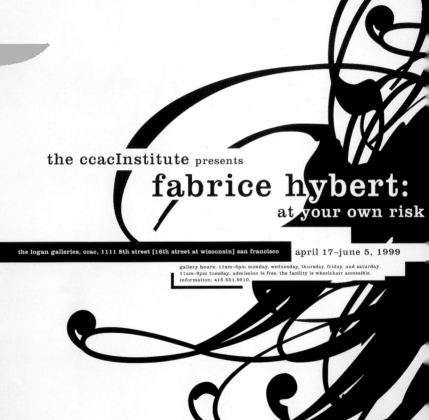

the ccacInstitute presents

fabrice hybert:
at your own risk

the logan galleries, ccac, 1111 8th street [16th street at wisconsin] san francisco april 17–june 5, 1999

gallery hours: 11am–5pm monday, wednesday, thursday, friday, and saturday.
11am–9pm tuesday. admission is free. the facility is wheelchair accessible.
information: 415.551.9210.

***CCAC posters—continued

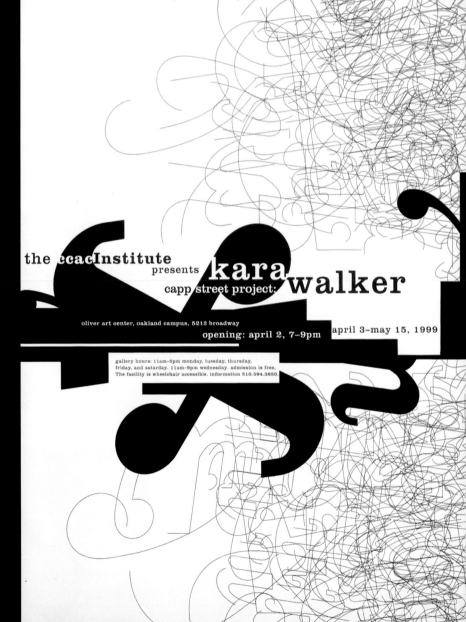

the ccacInstitute

presents kara walker

capp street project:

oliver art center, oakland campus, 5212 broadway

opening: april 2, 7–9pm

april 3–may 15, 1999

gallery hours: 11am–5pm monday, tuesday, thursday,
friday, and saturday. 11am–9pm wednesday. admission is free.
The facility is wheelchair accessible. information 510.594.3650.

the ccacInstitute

presents

spaced out:

late 1990s works from the collection of vicki and kent logan

the logan galleries, ccac, 1111 8th street [16th street at wisconsin] san francisco

april 17–june 5, 1999

gallery hours: 11am–5pm monday, wednesday, thursday, friday, and saturday. 11am–9pm tuesday. admission is free. the facility is wheelchair accessible. information: 415.551.9210.

★★★Exhibition poster

Friedhelm Plassmeier

CLIENT. Society for Christian and Jewish Partnership

DESIGNER. Friedhelm Plassmeier

AUSSTELLUNG

FOTOS AUS DEM WARSCHAUER GHETTO

Die Fotos werden von der Gesellschaft für Christlich-Jüdische Zusammenarbeit Paderborn e.V. zur Verfügung gestellt.

6. 11. – 27. 11. 01

Gymnasium St. Xaver
IN DER AULA

Öffnungszeiten: Während der Unterrichtszeit und nach Vereinbarung unter Bad Driburg Tel.: 0 52 53 / 40 22 53

★★★Prairie Sun poster

Tom & John: A Design Collaborative

CLIENT. Prairie Sun Recording Studios
ART DIRECTOR/DESIGNER. Tom Sieu
TOOLS. Photoshop, QuarkXPress, Macintosh
PAPER. Uncoated Industrial Recycled
PRINTING. Diazo

***Love Square & Circle

CLIENT. Museum Documentation Croatia

ART DIRECTOR/DESIGNER/ILLUSTRATOR.
Boris Ljubičić

TOOLS. Corel, PC
PAPER. Kunstdruck 250g
PRINTING. Silkscreen

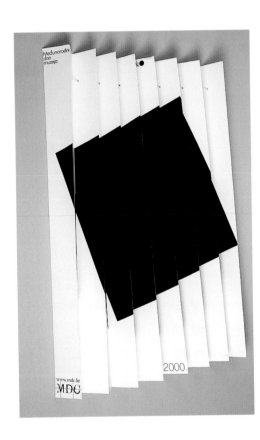

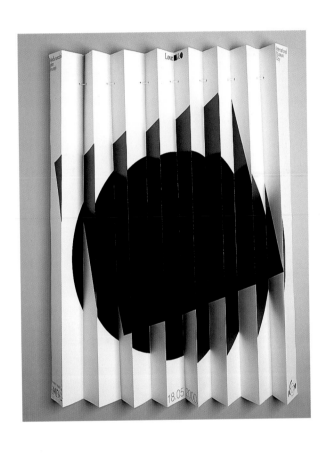

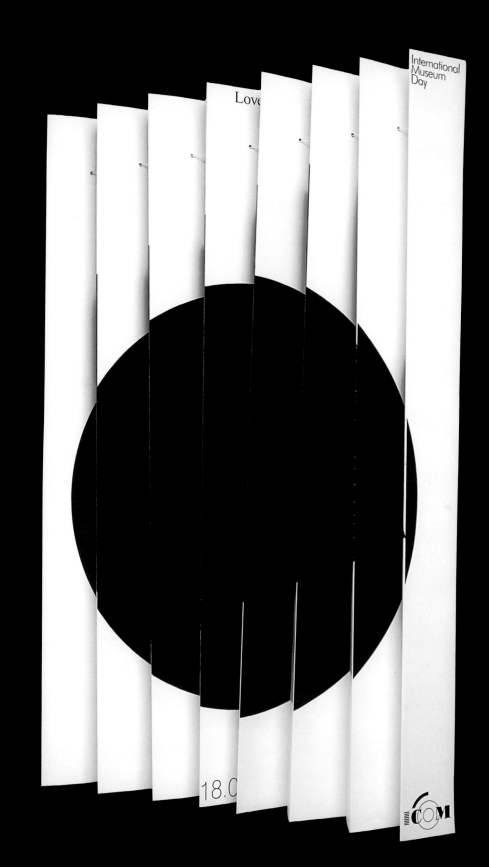

★★★"Art" poster

Lure Design, Inc.

CLIENT. Orlando-UCF Shakespeare Festival
DESIGNERS. Paul Mastriani, Jeff Matz

TOOLS. Illustrator, Photoshop
PAPER. Mohawk textures, Ultrafelt
PRINTING. Offset with embossing

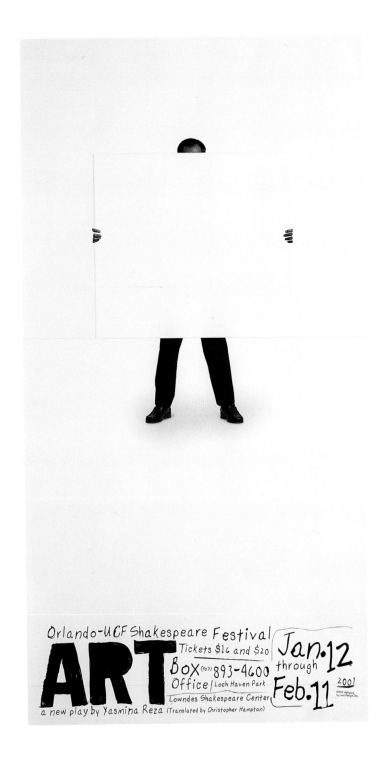

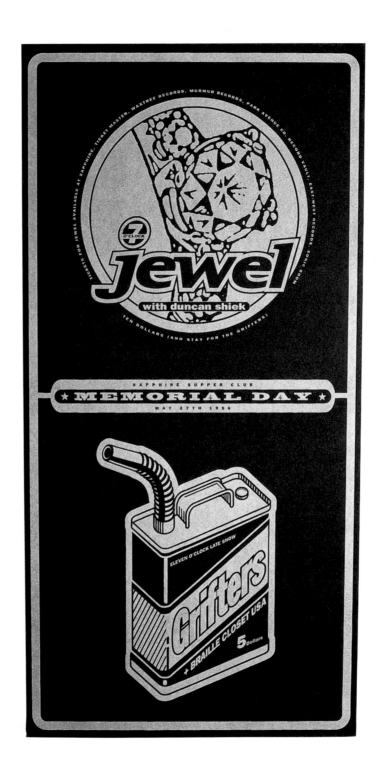

★★★"Woman in Black" posters

Lure Design, Inc.

CLIENT. Orlando–UCF Shakespeare Festival
DESIGNERS. Paul Mastriani, Jeff Matz
TOOLS. Illustrator, Photoshop

PAPER. Fraser Pegasus Midnight
Black Vellum
PRINTING. Offset, silver ink

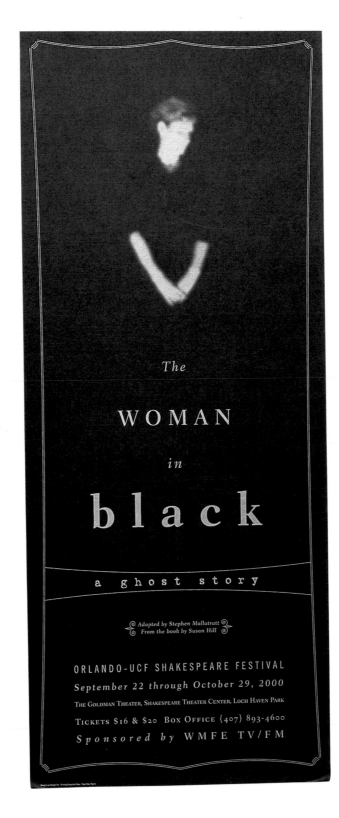

The

WOMAN

in

black

a ghost story

Adapted by Stephen Mallatratt
From the book by Susan Hill

ORLANDO-UCF SHAKESPEARE FESTIVAL

September 22 through October 29, 2000

THE GOLDMAN THEATER, SHAKESPEARE THEATER CENTER, LOCH HAVEN PARK

TICKETS $16 & $20 BOX OFFICE {407} 893-4600

Sponsored by WMFE TV/FM

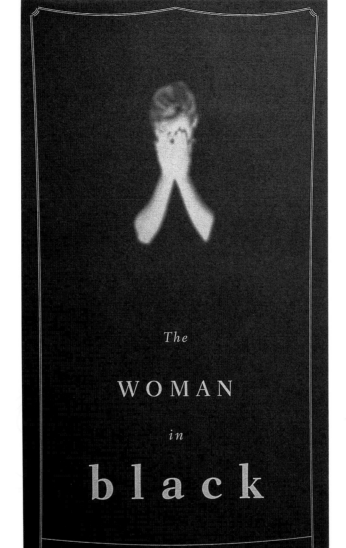

The

WOMAN

in

black

a ghost story

Adapted by Stephen Mallatratt
From the book by Susan Hill

ORLANDO-UCF SHAKESPEARE FESTIVAL

September 22 through October 29, 2000

THE GOLDMAN THEATER, SHAKESPEARE THEATER CENTER, LOCH HAVEN PARK

TICKETS $16 & $20 BOX OFFICE {407} 893-4600

Sponsored by WMFE TV/FM

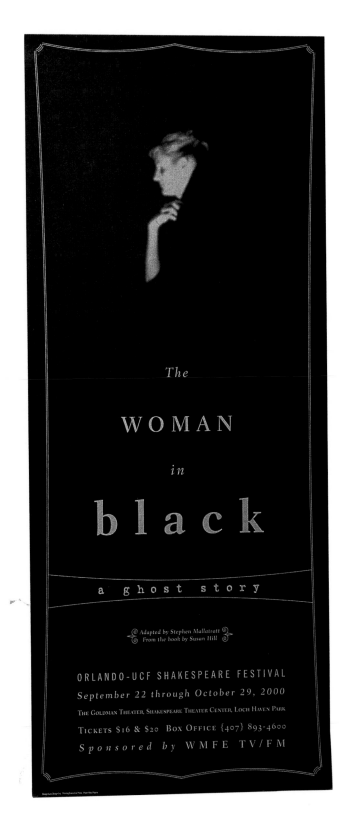

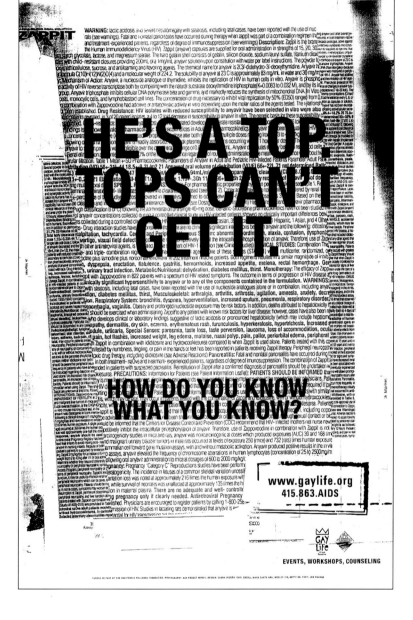

CLIENT. San Francisco AIDS Foundation
ART DIRECTOR. Raul Cabra
DESIGNERS. Mark Santa Ana, Wesley Ito,
Betty Ho
PHOTOGRAPHER. Ken Probst
TOOLS. QuarkXPress, Macintosh
PAPER. Cougar Untreated 86#C
PRINTING. Gateway Graphics

I DON'T HAVE IT YET. I MUST BE IMMUNE.

HOW DO YOU KNOW WHAT YOU KNOW?

www.gaylife.org
415.863.AIDS

EVENTS, WORKSHOPS, COUNSELING

FUNDED IN PART BY THE CALIFORNIA WELLNESS FOUNDATION. PHOTOGRAPHY KEN PROBST ©2001. DESIGN: CABRA DISEÑO, RAUL CABRA, MARK SANTA ANA, WESLEY IFE, BETTY HO. TEXT: JON ROEMER

HE'D TELL ME IF HE'S POSITIVE.

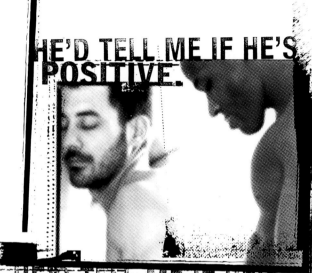

HE'D TELL ME IF HE'S NEGATIVE.

HOW DO YOU KNOW WHAT YOU KNOW?

www.gaylife.org
415.863.AIDS

 GAY Life AIDS

EVENTS, WORKSHOPS, COUNSELING

FUNDED IN PART BY THE CALIFORNIA WELLNESS FOUNDATION. PHOTOGRAPHY: KEN PROBST ©2001. DESIGN: CAHAN ©2000. PAUL CAHAN, MARA CARTA AND WESLEY ITO. ©2001 NO TEXT: JON KRAMER

★★★Archers of Loaf poster

Lure Design, Inc.

CLIENT. Figurehead Records
DESIGNER/ILLUSTRATOR. Jeff Matz

TOOLS. Illustrator, Photoshop
PAPER. Chipboard
PRINTING. Silkscreen

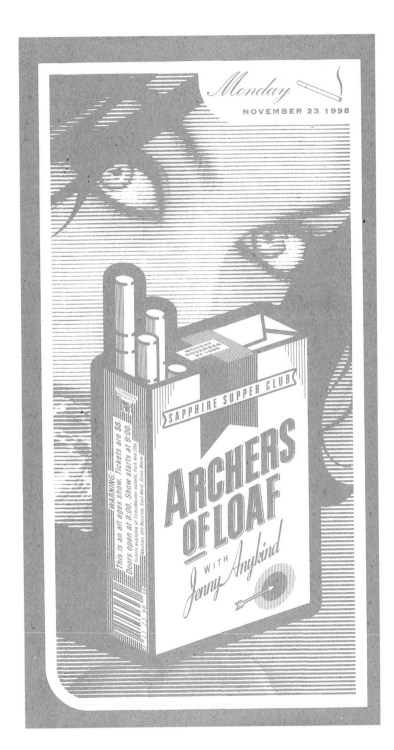

FIGUREHEAD AND PARK AVE CDS PRESENT

SAPPHIRE SUPPER CLUB

Elliott Smith

with no.2

TEN DOLLARS GENERAL ADMISSION

DOORS OPEN AT 8:00 SHOW AT 9:00

THIS IS AN ALL AGES SHOW

TICKETS AT ALL TICKETMASTER LOCATIONS

PARK AVE CDS, WAX TREE, SONIC BOOM

AND EAST WEST RECORDS

MONDAY March 15

***Multimedia Institute MIz

Arkzin d.o.o.

CLIENT. Multimedia Institute Miz,
Zagreb, Croatia

ART DIRECTOR. Dejan Dragosavac-Rutta

DESIGNERS. Dejan Dragosavac, Dejan Kršić

TOOLS. Freehand, Photoshop

PRINTING. Offset

Buffers Files Tools Edit Search Mule IM-Python Python Help

<re:Con>

Međunarodna izložba softvera,
umjetnosti i igara koje
re:flektiraju promjene u
kompjuterskoj kulturi.

```
> I/O/D ..............(London_UK)
> Christoph Kummerer ..(Beč_A)
> AudioRom ...........(London_UK)
> delire .............(AU/NZ)
> Mongrel ............(UK/JAM)
> zzkt ...............(AU/B)
```

Na otvorenju najavljujemo
<re:Play>, performans umjetnika
koji se bave zvukom.

* Galerija proširenih medija

<OTVORENJE>
SRIJEDA_26/09/2001_19h

<RADNO VRIJEME>
radnim danom 11-19h
(osim subotom i nedjeljom 10-14h)
Izložba ostaje otvorena
do 01/10/2001

--1-:**-F1 poster.py (Python)- --1-:**-F1 plakat.py

Buffers Files Tools Edit Search Mule IM-Python Python Help

<re:Think>

Večer diskusije i prezentacije koje
re:interpretiraju teme izložbe <re:Con>
iz kulturne, političke i teorijske
perspektive.

SUDJELUJU...
```
> Julian OLIVER .......(delire)
> Andre KTORI .........(Audiorom)
> Richard Pierre DAVIS (Mongrel)
> Christoph KUMMERER
> Honor HARGER .......(radioqualia)
```

* net.kulturni klub_mama
 ČETVRTAK_27/09/2001_19-21h

<re:Do>

Laboratorij koji potiče izravne odogovore
tehnologiji kroz seriju radionica o
streaming medijima, skriptingu
i Mongrelovom Linker softveru.

* mi2lab_PETAK_28/09/2001

--1-:**-F1 poster.py (Python)- --1-:**-F1 plakat.py

KUSTOSI...
radioqualia
<www.radioqualia.net>
& Marcell Mars

ORGANIZATORI...
Hrvatsko društvo
likovnih umjetnika
46 11 818 46 11 819
<hdlu-zg@zg.tel.hr>

Multimedijalni
Institut
48 56 400
<mama@mi2.hr>

MJESTA ODRŽAVANJA..
* GALERIJA PROŠIRENIH MEDIJA
 Dom Hrvatskog društva
 likovnih umjetnika
 Trg žrtava fašizma bb
 Zagreb
* NET.KULTURNI KLUB_MAMA
 Preradovićeva 18_Zagreb
* MI2LAB
 Gundulićeva 35/1_Zagreb

* DIZAJN...
 jela/dk/rutta(ARKZIN)
 marcell(ShefOOnarta)

1 C / e
MACRO

★★★2000 MFA Exhibit poster
University of Washington

CLIENT. University of Washington
School of Art
DESIGNER. Karen Cheng

TOOLS. Illustrator, Macintosh
PAPER. Lustro Archival Dull 100 #T
PRINTING. Olympus Press

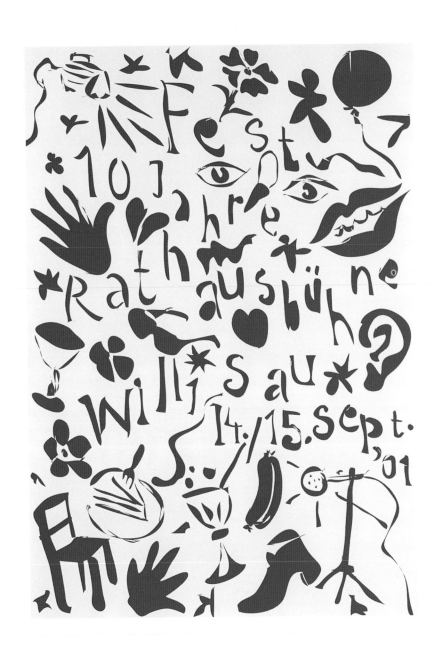

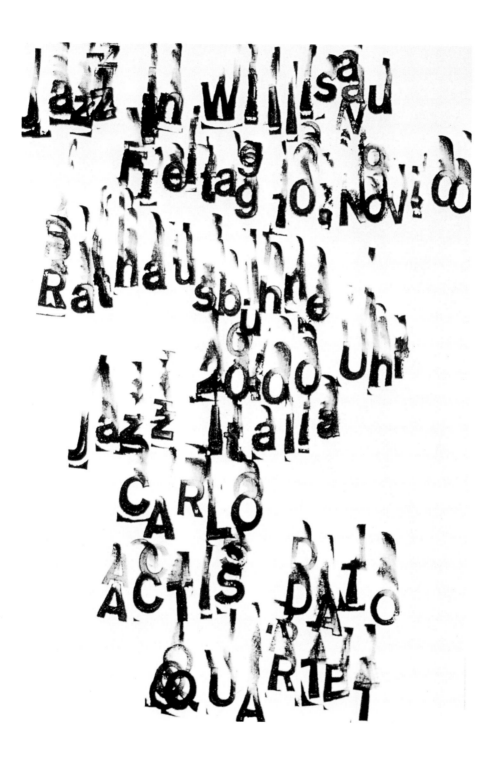

★★★Jazz in Willisau poster
Niklaus Troxler Design

PAPER. Poster, 90.5 x 128 cm
PRINTING. Silkscreen

CLIENT. Jazz in Willisau
ART DIRECTOR/DESIGNER. Niklaus Troxler

***Jazz in Willisau poster

Niklaus Troxler Design

CLIENT. Jazz in Willisau
ART DIRECTOR/DESIGNER. Niklaus Troxler
PAPER. Poster, 90.5 x 128 cm
PRINTING. Silkscreen

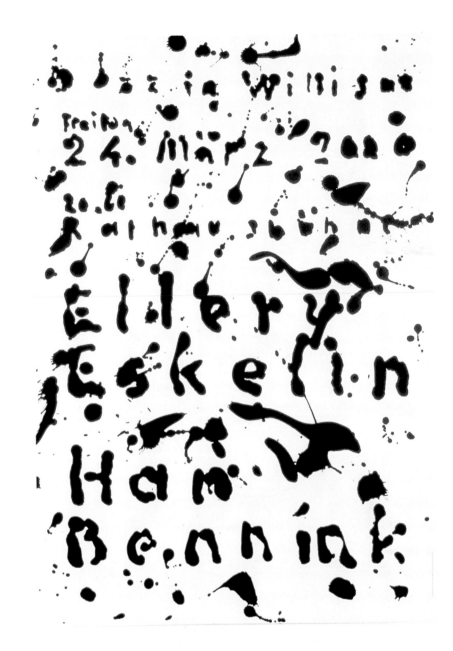

★ ★ ★ ArtHip! Masquerade Ball poster

Shoehorn Design

ILLUSTRATOR. Will Hornaday

TOOLS. Illustrator, Macintosh

PAPER. Quantum Opaque White 80#C

PRINTING. The Whitley Company

CLIENT. Austin Museum of Art

ART DIRECTOR. Will Hornaday

DESIGNERS. Ted Roddy, Will Hornaday

LAKE

★★★October 18 lecture poster

Jennifer Sterling Design

CLIENT. California College of Arts and Crafts
ART DIRECTOR/DESIGNER. Jennifer Sterling
TOOLS. Illustrator, Photoshop, Macintosh

MATERIALS. Lexan
PRINTER. Bel Aire Display

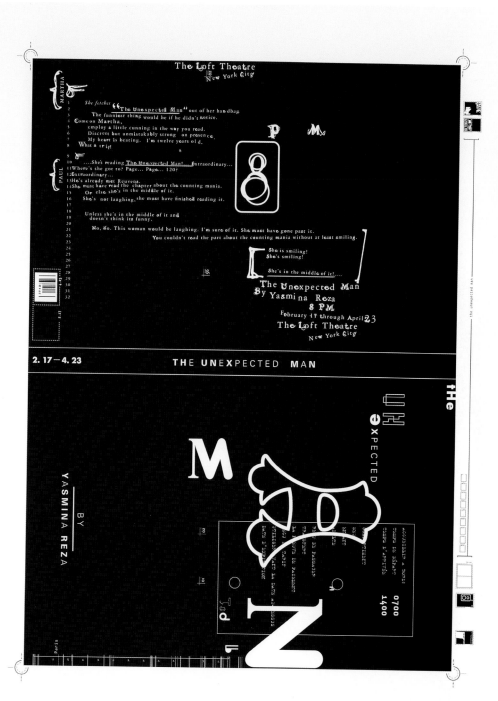

★★★Unexpected Man poster
Jennifer Sterling Design

CLIENT. *Critique* magazine
ART DIRECTOR/DESIGNER. Jennifer Sterling
TOOLS. Illustrator, Macintosh
PAPER. Arches Watercolor
PRINTING. Trillium

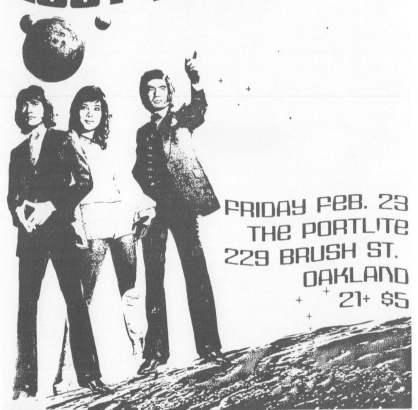

THE PATTERN
HEART OF SNOW
LOST KIDS

FRIDAY FEB. 23
THE PORTLITE
229 BRUSH ST.
OAKLAND
21+ $5

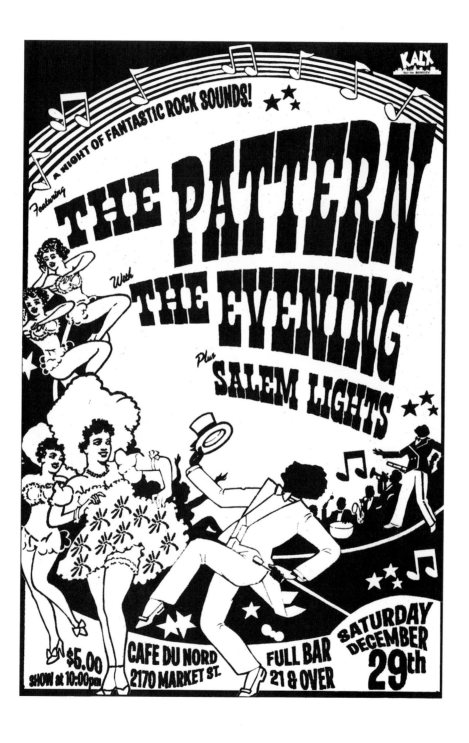

★★★Café du Nord poster

Red Alert Visuals

TOOLS. QuarkXPress, Photoshop, Streamline
PAPER. 60# Coated
PRINTING. Hand-screened

CLIENT. Café du Nord
ART DIRECTOR/DESIGNER. Jason Rosenberg

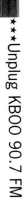

116

C / G

MACRO

Cheevers

***Unplug KBOO 90.7 FM

CLIENT. Advocates for KBOO Community Radio
ART DIRECTOR/DESIGNER/ILLUSTRATOR. Tom Cheevers
TOOLS. QuarkXPress, Photoshop, Macintosh, photocopy

PAPER. French Dur-O-Tone Aged Newsprint
PRINTING. Kinkos

Left poster

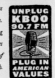

LISTENING TO THE RADIO MAY BE

TURNING YOU INTO A HOMOSEXUAL.

With programs like "THIS WAY OUT" and "QUEER, QUEER WORLD," it's obvious what flag of pride KBOO [90.7 FM] is waving — and it's not the Stars and Stripes. Your teenager may be LISTENING to rock & roll one minute and the next it being HYPNOTIZED by subliminal homosexual recruitment messages. They call themselves GAY but there's nothing happy about seeing a child sucked down the slippery slope of moral decay. The Sodomites at KBOO [90.7 FM] have VIOLATED our ears long enough. Straighten out, America! Resist KBOO [90.7 FM] and resist the DEVIL'S DESIRES.

UNPLUG KBOO 90.7 FM — PLUG IN AMERICAN VALUES

CONVINCED? VOTE BELOW!

☐ **YES!** Unplug KBOO before it's TOO LATE!

SEND $5 FOR YOUR BUMPER STICKER.
Name: _____
Address: ___ City: ___ State: ___ Zip: ___
Send To: UNPLUG KBOO, 408 SW 2nd Ave. Suite 411, Portland, Oregon 97104

☐ **NO!** Don't unplug KBOO. I like it PLUGGED IN.

★ ★ ★ PAID FOR BY THE COALITION OF INTOLERANT AMERICANS ★ ★ ★

e-mail: UNPLUGKBOO@AOL.COM

Right poster

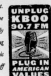

TRIP-HOP SALSA FUNK: YOUR RADIO CAN GET YOUR DAUGHTER PREGNANT.

It starts innocently enough. A group of young people gather at the home of an ABSENT parent. Then someone tunes the radio to KBOO [90.7 FM]. As darkness falls, the room fills with the PULSING rhythms of the station's sexually suggestive melodies. Soon all are rhythmically gyrating to the lewd beat of SATAN'S hellish heart. For some unlucky woman this living nightmare may end nine months later with an unexpected dance partner. For LIFE. If this picture of moral CORRUPTION scares you, turn on traditional family values by turning off the most DESTRUCTIVE force in America today: KBOO [90.7 FM] radio.

UNPLUG KBOO 90.7 FM — PLUG IN AMERICAN VALUES

CONVINCED? VOTE BELOW!

☐ **YES!** Unplug KBOO before it's TOO LATE!

SEND $5 FOR YOUR BUMPER STICKER.
Name: _____
Address: ___ City: ___ State: ___ Zip: ___
Send To: UNPLUG KBOO, 408 SW 2nd Ave. Suite 411, Portland, Oregon 97104

☐ **NO!** Don't unplug KBOO. I'm trying to GET PREGNANT!

★ ★ ★ PAID FOR BY THE COALITION OF INTOLERANT AMERICANS ★ ★ ★

e-mail: UNPLUGKBOO@AOL.COM

WHEN KBOO RADIO SHOVES THE GRATEFUL DEAD DOWN YOUR THROAT, THE EVIL WEED IS SURE TO FOLLOW.

At KBOO [90.7 FM] the psychopharmacological hell-hole that was the 60s never ended. It lives on in the form of "THE GRATEFUL DEAD HOUR," a mind-numbing collection of "BOOGIE JAMS." If the entire nation followed the pied-piper call of these hacky-sack hooligans, where would we be? Stuck on a collective farm answering "YES, COMRADE" to our Communist enslavers. It's time for these FREE-LOVE freaks to put down their pipes, shave their DREADLOCKS, enlist in the Army and become God-fearing Americans. Unplug KBOO [90.7 FM] before the stench of pot smoke makes us all coke-headed ZOMBIES.

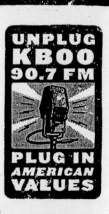

UNPLUG KBOO 90.7 FM

PLUG IN AMERICAN VALUES

CONVINCED? VOTE BELOW!

SEND $5 FOR YOUR BUMPER STICKER.

YES!
Unplug KBOO before it's TOO LATE!

Name: _____

Address: _____ City: _____ State: ____ Zip: _____

Send To: UNPLUG KBOO, 408 SW 2nd Ave. Suite 411, Portland, Oregon 97204

NO!
Don't unplug KBOO. Jerry's not dead, he just SMELLS FUNNY.

★ ★ ★ **PAID FOR BY THE COALITION OF INTOLERANT AMERICANS** ★ ★ ★

e-mail: UNPLUGKBOO@AOL.COM

★★★"No Matter" poster

MATTER

CLIENT. MATTER
ART DIRECTOR. Jason C. Otero

DESIGNERS. Jason C. Otero, Rick Griffith,
Joe Lamarre, Shennon Murray,
Paco Proano

TOOLS. Imagination, Bare Hands
PAPER. Various
PRINTING. Screenprinting

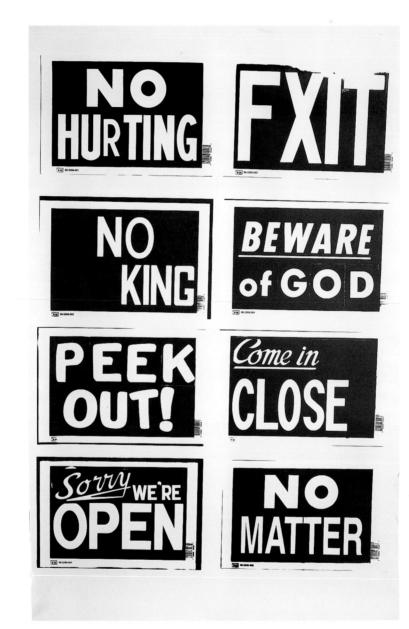

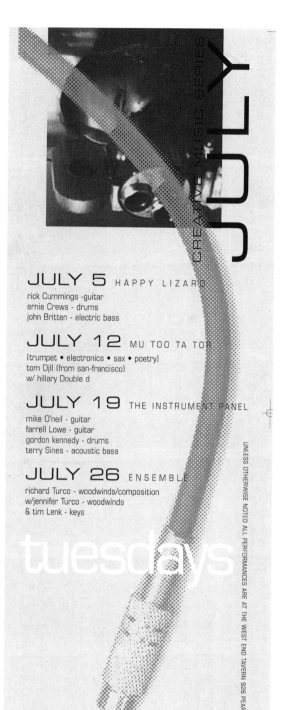

CREATIVE MUSIC SERIES

JULY

JULY 5 HAPPY LIZARD

rick Cummings -guitar
ernie Crews - drums
john Britten - electric bass

JULY 12 MU TOO TA TOR

[trumpet • electronics • sax • poetry]
tom Djll (from san-francisco)
w/ hillary Double d

JULY 19 THE INSTRUMENT PANEL

mike O'neil - guitar
farrell Lowe - guitar
gordon kennedy - drums
terry Sines - acoustic bass

JULY 26 ENSEMBLE

richard Turco - woodwinds/composition
w/jennifer Turco - woodwinds
& tim Lenk - keys

tuesdays

for more information call (303) 440-5638
design: rick griffith design, boulder

★★★An Audio Obstacle Course

CLIENT. Creative Music Series

ART DIRECTOR/DESIGNER. Rick Griffith

TOOLS. QuarkXPress, Macintosh

PAPER/PRINTING. Blueline

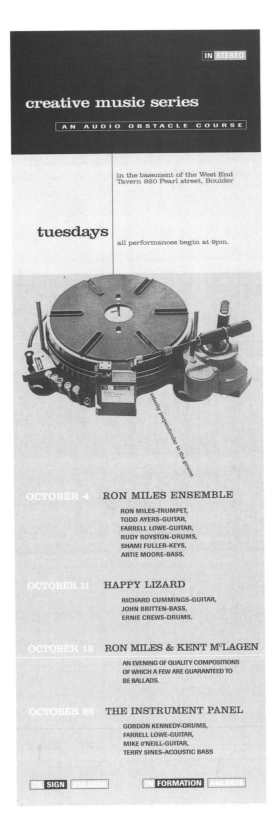

IN STEREO

creative music series

AN AUDIO OBSTACLE COURSE

in the basement of the West End Tavern 920 Pearl street, Boulder

tuesdays

all performances begin at 9pm.

velocity perpendicular to the groove

OCTOBER 4 RON MILES ENSEMBLE

RON MILES-TRUMPET,
TODD AYERS-GUITAR,
FARRELL LOWE-GUITAR,
RUDY ROYSTON-DRUMS,
SHAMI FULLER-KEYS,
ARTIE MOORE-BASS.

OCTOBER 11 HAPPY LIZARD

RICHARD CUMMINGS-GUITAR,
JOHN BRITTEN-BASS,
ERNIE CREWS-DRUMS.

OCTOBER 18 RON MILES & KENT McLAGEN

AN EVENING OF QUALITY COMPOSITIONS
OF WHICH A FEW ARE GUARANTEED TO
BE BALLADS.

OCTOBER 25 THE INSTRUMENT PANEL

GORDON KENNEDY-DRUMS,
FARRELL LOWE-GUITAR,
MIKE O'NEILL-GUITAR,
TERRY SINES-ACOUSTIC BASS

DE SIGN 938.8356 IN FORMATION 440.5638

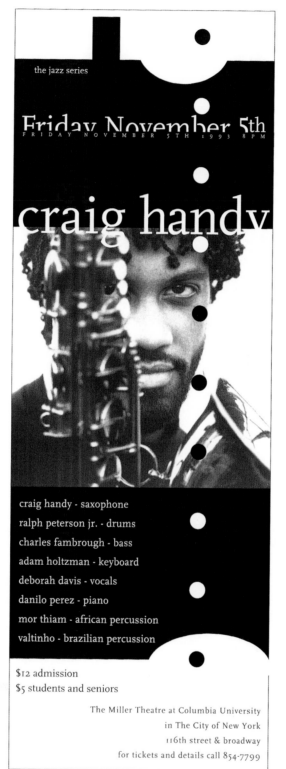

the jazz series

Friday November 5th
FRIDAY NOVEMBER 5TH 1993 8PM

craig handy

craig handy - saxophone

ralph peterson jr. - drums

charles fambrough - bass

adam holtzman - keyboard

deborah davis - vocals

danilo perez - piano

mor thiam - african percussion

valtinho - brazilian percussion

$12 admission
$5 students and seniors

The Miller Theatre at Columbia University
in The City of New York
116th street & broadway
for tickets and details call 854-7799

★★★The Jazz Series: Craig Handy poster

TOOLS. QuarkXPress, Macintosh
PAPER/PRINTING. Brownline

CLIENT. Miller Theater
ART DIRECTOR/DESIGNER. Rick Griffith

***Innerschweizer Filmtage poster

Mix Pictures Grafik

CLIENT. Kleintheater Luzern
ART DIRECTOR/DESIGNER.
Erich Brechbühl

TOOLS. Freehand, Macintosh
PAPER. Poster
PRINTING. Silkscreen

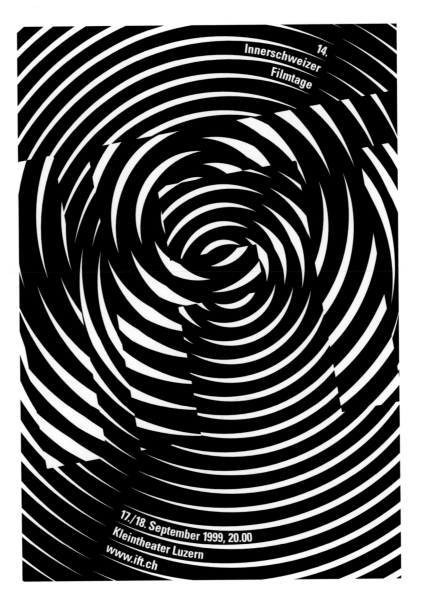

14.
Innerschweizer
Filmtage

17./18. September 1999, 20.00
Kleintheater Luzern
www.ift.ch

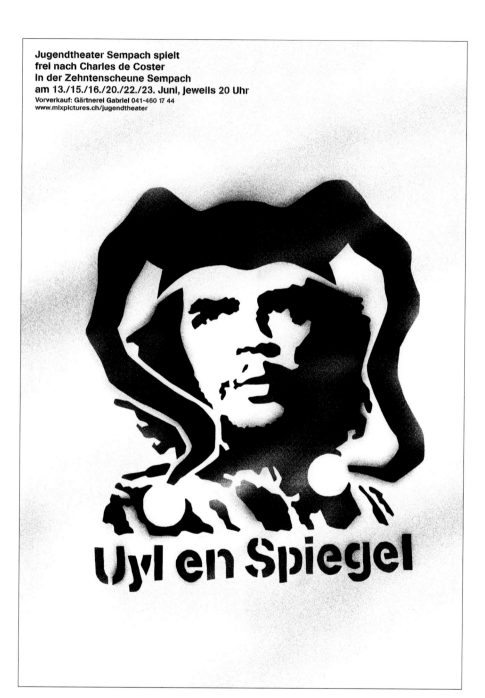

Jugendtheater Sempach spielt
frei nach Charles de Coster
In der Zehntenscheune Sempach
am 13./15./16./20./22./23. Juni, jeweils 20 Uhr
Vorverkauf: Gärtnerei Gabriel 041-460 17 44
www.mixpictures.ch/jugendtheater

Uyl en Spiegel

★★★Jugendtheater Sempach poster

Mix Pictures Grafik

TOOLS. Photoshop, Macintosh
PAPER. Poster
PRINTING. Silkscreen

CLIENT. Jugendtheater Sempach
ART DIRECTOR/DESIGNER. Erich Brechbühl

123
1C/3
MACRO

4

MICRO
AN INTIMATE IMPRESSION
invitations / announcements

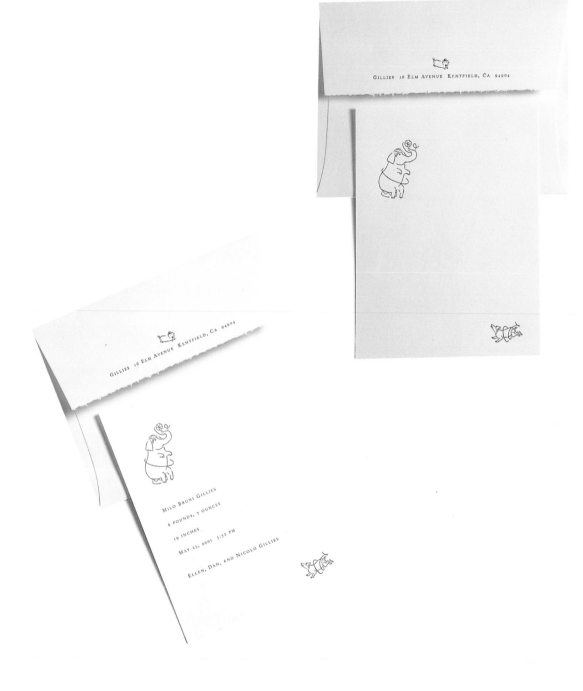

CLIENTS. Ellen Bruni-Gillies & Dan Gillies
ART DIRECTOR/DESIGNER. Ellen Bruni-Gillies
ILLUSTRATOR. Ward Shumacher

TOOLS. QuarkXPress, Photoshop, Macintosh
PAPER. Fox River Teton Tiara White
PRINTING. Full Circle Press

★★★Milo birth announcement

Ellen Bruni-Gillies Design

MANISCALCO
1010 D STREET
PETALUMA
CA 94952

Tony, Nicolas & Melinda Maniscalco
celebrate the *miraculous* arrival of

~ *Luca Isabella Maniscalco* ~

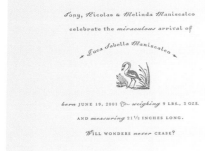

born JUNE 19, 2001 ☞ *weighing* 9 LBS., 5 OZS.

AND *measuring* 21 ½ INCHES LONG.

*W*ILL WONDERS *never* CEASE?

MANISCALCO
1010 D STREET
PETALUMA
CA 94952

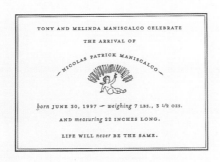

TONY AND MELINDA MANISCALCO CELEBRATE

THE ARRIVAL OF

~ NICOLAS PATRICK MANISCALCO ~

born JUNE 30, 1997 — *weighing* 7 LBS., 3 ½ OZS.

AND *measuring* 22 INCHES LONG.

LIFE WILL *never* BE THE SAME.

CLIENTS. Melinda and Tony Maniscalco
ART DIRECTORS/DESIGNERS. Melinda and Tony Maniscalco
ILLUSTRATOR. Clip art
TOOLS. Illustrator, Macintosh
PRINTING. Full Circle Press

★★★Nicolas and Luca birth announcements

Homespun Design

MICRO

127

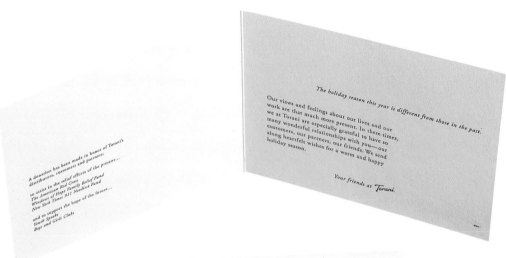

A donation has been made in honor of Torani's
distributors, customers and partners;

to assist in the relief efforts of the present...
The American Red Cross
Windows of Hope Family Relief Fund
New York Times 911 Needless Fund

and to support the hope of the future...
Youth Speaks
Boys and Girls Clubs

The holiday season this year is different from those in the past.
Our views and feelings about our lives and our
work are that much more present. In these times,
we at Torani are especially grateful to have so
many wonderful relationships with you—our
customers, our partners, our friends. We send
along heartfelt wishes for a warm and happy
holiday season.

Your friends at Torani.

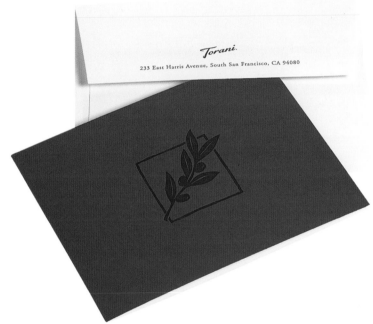

Torani.
233 East Harris Avenue, South San Francisco, CA 94080

CLIENT. Torani
ART DIRECTOR/ILLUSTRATOR.
Laura Bauer

DESIGNER. Gary Wong
TOOLS. Illustrator, Macintosh
PRINTING. Full Circle Press

★★★ Torani holiday card

Anvil Graphic Design

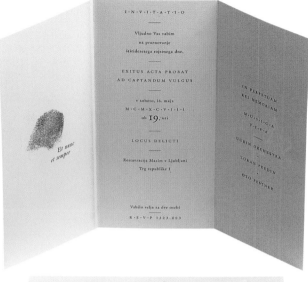

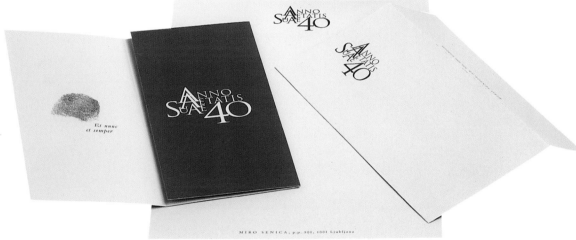

CLIENT. Miro Senica

ART DIRECTOR/DESIGNER. Edi Berk

TOOLS. Illustrator, Macintosh

PAPER. Conqueror Vergata

PRINTING. Offset

★★★Anno Aetatis Suae 40 invitation

KROG

The VENTURA COUNTY STAR and the
VENTURA COUNTY MEDICAL RESOURCE FOUNDATION
present the

NINTH ANNUAL
DAVID C. FAINER M.D.
AWARDS DINNER

PROGRAM RECORD

CLINIC OFFICE: SPANISH HILLS GOLF & COUNTRY CLUB

THIS RECORD MAY BE REMOVED FROM THE SITE

Feel free to remove this record from designated area
without notifying Medical Records

INFORMATION IN THIS RECORD IS NOT CONFIDENTIAL

PATIENT'S NAME
LAST
FIRST
MIDDLE

2005	2004	2003	2002	2001	2000	1999	1998	1997	1996	1995	1994	1993

PRESCRIPTION

Name: NINTH ANNUAL DAVID C. PAINER M.D. AWARDS DINNER

Date: NOVEMBER 2, 2001

Place: SPANISH HILLS GOLF & COUNTRY CLUB

Attire: BLACK TIE OPTIONAL

Evening Festivities

Sig: Silent Auction & No-Host Bar 6:15 pm

Dinner/Program 7:45 pm

Disp: One fun Evening!

Instructions: Register early for best bed assignment

John Keats, M.D.
Master of Ceremonies

Refill: Annually

VGS

VENTURA COUNTY
MEDICAL RESOURCE FOUNDATION
250 Citrus Grove Lane Suite 240
Oxnard, California 93030

ADDRESS SERVICE REQUESTED

Ninth Annual David C. Painer M.D. Awards Dinner

HISTORY and PHYSICAL

Please fill out and take a seat. The Doctor will be with you shortly.

Name: _____

Address: _____

City: _____ State: _____ Zip: _____

Telephone: _____

[] I/We want to be a Gold Sponsor for $2,500* with VIP seating for 12.
(Includes 1/4 page ad in program, recognition as Gold sponsor in publicity materials and at dinner.)

[] I/We want to be a Silver Sponsor for $1,000* with VIP seating for 4.
(Includes 1/8 page ad in program, recognition as Silver sponsor in publicity materials and at dinner.)

[] I/We want to be a Bronze Sponsor for $500* with VIP seating for 2.

[] I/We would like to reserve _____ tables(s) of 12 at $1,800 ($900 tax-deductible*)

[] I/We would like to reserve _____ seat(s) at $150 per person ($75 tax-deductible*)

[] I/We are unable to attend. Please accept $_____ as a tax-deductible contribution.
Please make check to: VCMRF

Total: $_____ [] Check Enclosed. Please make check to: VCMRF
 [] Master Card [] Visa Expir. Date: _____

Card Number: _____

Card Member Name: _____

Signature: _____ by October 23, 2001. Please Mail or FAX to (805) 485-0416

Reservations will be held at the door.

I've schedu...

appoint...

DIAGNOSIS:

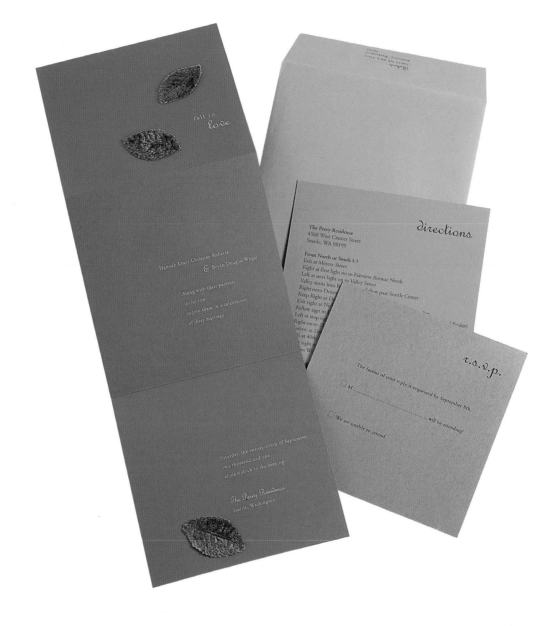

CLIENTS. Hannah Roberts, Bryan Wygal
ART DIRECTOR. Hannah Wygal
DESIGNERS. Hannah Wygal, Theresa Veranth

TOOLS. Freehand
PAPER. French Construction
PRINTING. The Press

★★★Roberts & Wygal wedding invitation

Monster Design

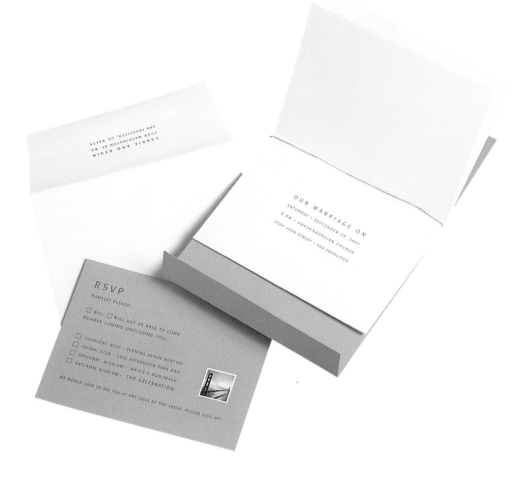

RSVP

NAME(S) PLEASE:

☐ WILL ☐ WILL NOT BE ABLE TO COME
NUMBER COMING (INCLUDING YOU):

☐ THURSDAY, 9/27 · EVENING BEACH BONFIRE
☐ FRIDAY, 9/28 · LATE AFTERNOON PARK BBQ
☐ SATURDAY 9/29/AM · BRIDE'S RUN/WALK
☐ SATURDAY 9/29/PM · THE CELEBRATION

WE WOULD LOVE TO SEE YOU AT ANY (ALL) OF THE ABOVE. PLEASE SIGN UP!

OUR MARRIAGE ON

SATURDAY · SEPTEMBER 29, 2001
5 PM · SWEDENBORGIAN CHURCH
2107 LYON STREET · SAN FRANCISCO

CARRIE AND KEVIN
2580 WASHINGTON ST. #5
SAN FRANCISCO, CA 94115

CLIENTS. Carrie Taylor, Kevin McPeek
ART DIRECTORS/DESIGNERS. Lesley
Hathaway, Eve Billig
TOOLS. QuarkXPress, Illustrator
PAPER. Synergy Orange Felt (cover),
Nekoosa Natural Felt (inside)
PRINTING. Full Circle Press

★★★ "The Daffodil" wedding invitation
A Day in May Design

MICRO
133

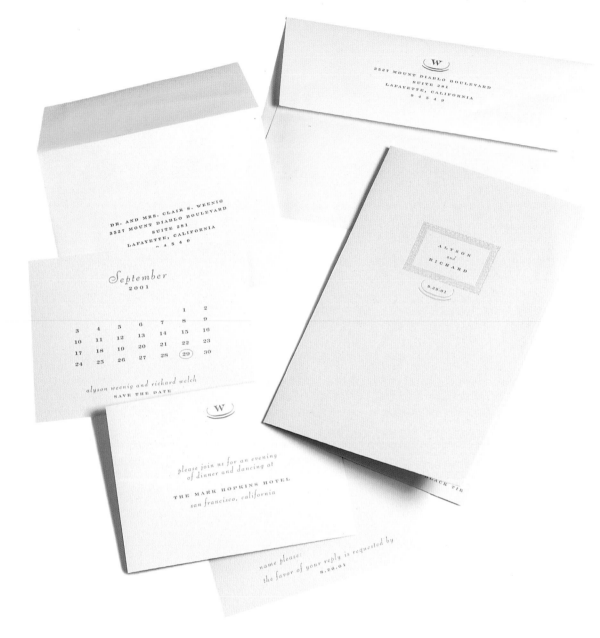

CLIENTS: Alyson Weenig, Richard Welch

ART DIRECTORS/DESIGNERS: Lesley
Hathaway, Eve Billig

TOOLS: QuarkXPress, Illustrator
PAPER: Nekoosa Natural Felt
PRINTING: Full Circle Press

★★★"The Lily" wedding invitation

A Day in May Design

KENDALL PARK, NEW JERSEY 08824

17 JOAN STREET

August

2001

		1	2	3	4	5
6	7	8	9	10	(11)	10
13	14	15	16	17	18	19
20	21	22	23	24	25	26
27	28	29	30	31		

ANNE MAYER AND SEAN GREGORY
save the date

A**g**s

A**g**s

MR. AND MRS. DENIS MAYER

MR. AND MRS. CHRISTOPHER GREGORY

* REQUEST THE PLEASURE OF YOUR COMPANY

AT THE MARRIAGE OF THEIR CHILDREN

ANNE ELIZABETH MAYER

AND

SEAN MICHAEL GREGORY

ON SATURDAY THE ELEVENTH OF AUGUST

TWO THOUSAND AND ONE

AT FOUR O'CLOCK

PRINCETON UNIVERSITY CHAPEL

PRINCETON, NEW JERSEY

FOLLOWING THE CEREMONY

PLEASE JOIN US AT THE CAP AND GOWN CLUB

FOR AN EVENING OF DINNER AND DANCING

CLIENTS. Anne Mayer, Cristopher Gregory
ART DIRECTORS/DESIGNERS.
Lesley Hathaway, Eve Billig
TOOLS. QuarkXPress, Illustrator
PAPER. Carrara White Feltweave
PRINTING. Full Circle Press

A**g**s

★★★"The Petunia" wedding invitation

A Day in May Design

MICRO

135

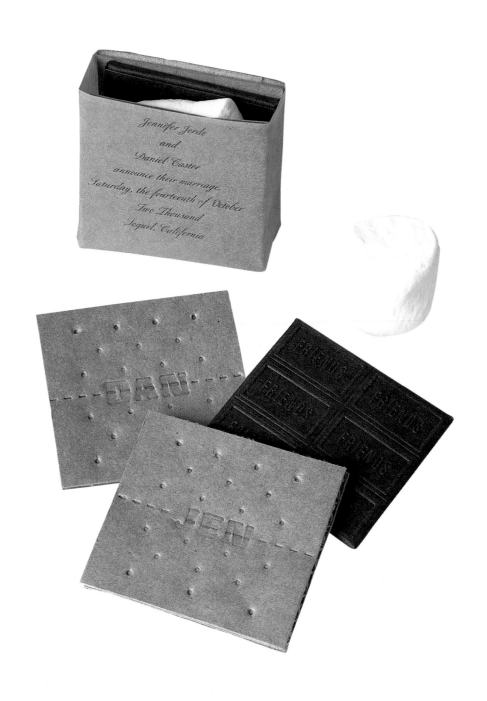

Jennifer Jerde
and
Daniel Castor
announce their marriage.
Saturday, the fourteenth of October
Two Thousand
Soquel, California

CLIENTS. Jennifer Jerde, Daniel Castor
ART DIRECTOR/DESIGNER. Jennifer Jerde

PAPER. Gmund, Cardboard, Wax Paper
PRINTING. Dickson's, Inc.

★★★Jerde & Castor wedding invitation

Elixir Design

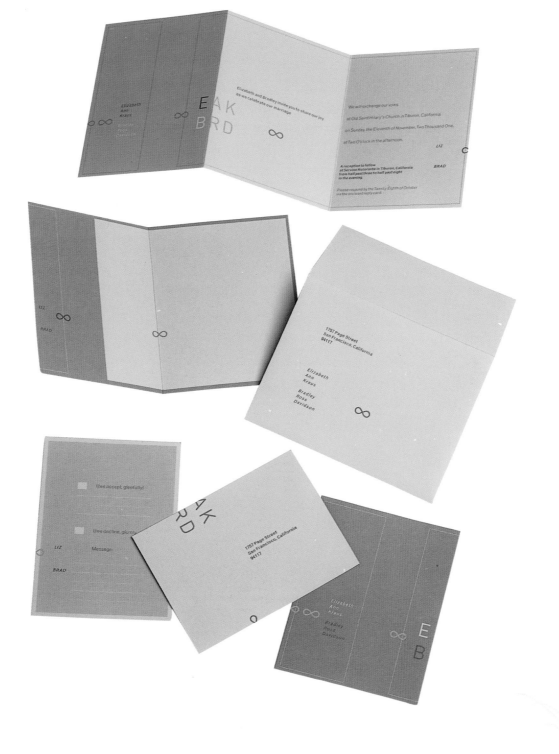

CLIENTS. Brad Davidson, Liz Kraus TOOLS. Illustrator, Macintosh
ART DIRECTOR. Todd Foreman PAPER. French Frostone
DESIGNER. Tessa Lee PRINTING. Quad Express

★★★Davidson & Kraus wedding invitation

Public

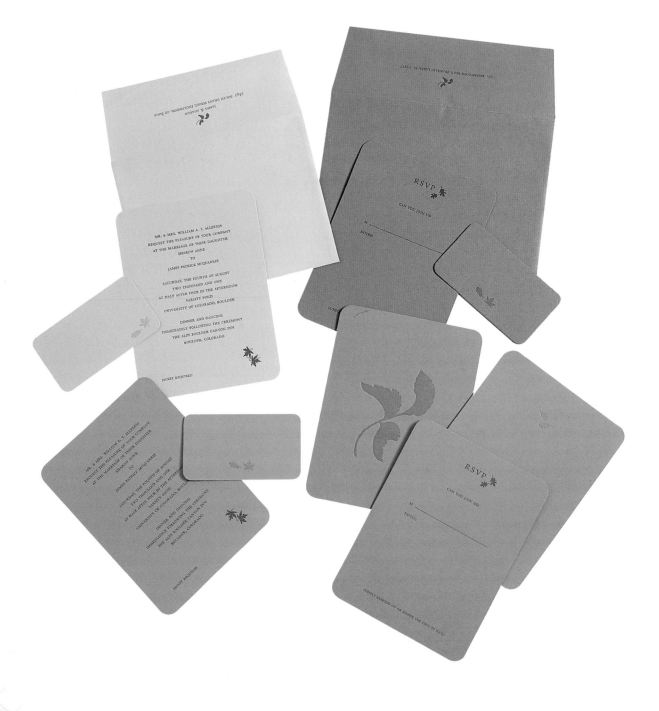

CLIENTS: Sharon Allpress, James McQuarrie
ART DIRECTORS/DESIGNERS: Lesley Hathaway, Eve Billig
TOOLS: QuarkXPress, Illustrator
PAPER: French Construction
PRINTING: Full Circle Press

★★★"The Dahlia" wedding invitation

A Day in May Design

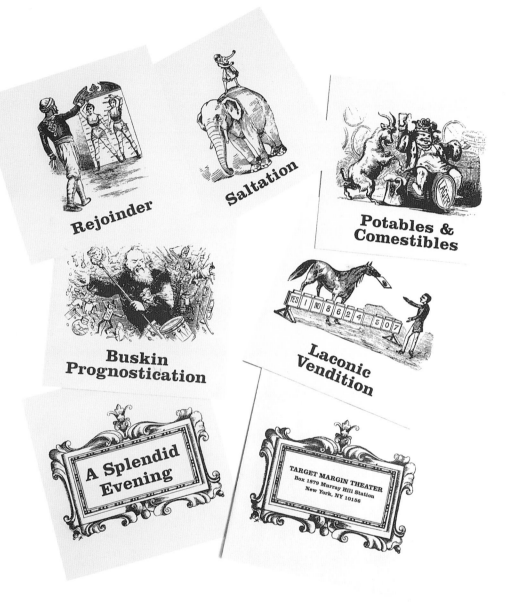

Rejoinder

Saltation

Potables &
Comestibles

Buskin
Prognostication

Laconic
Vendition

A Splendid
Evening

TARGET MARGIN THEATER
Box 1879 Murray Hill Station
New York, NY 10156

CLIENT. Target Margin Theater TOOLS. QuarkXPress, Macintosh
ART DIRECTOR/DESIGNER. PRINTING. Offset
Noah Scalin

★★★"A Splendid Evening" invitation

ALR Design

MICRO

139

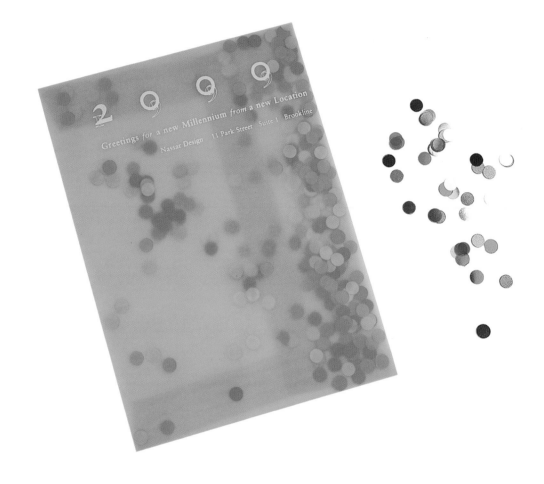

CLIENT. Nassar Design
ART DIRECTOR/DESIGNER. Nelida Nassar

TOOLS. QuarkXPress, Illustrator
PAPER. Cromatica
PRINTING. Silkscreen

★★★New Millenium greeting

Nassar Design

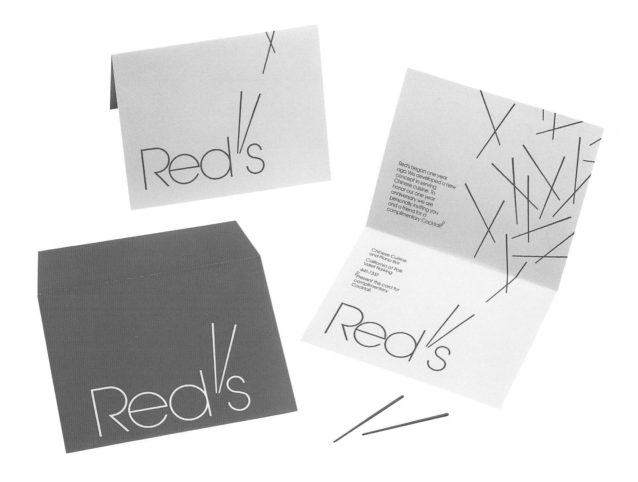

Red's began one year ago. We developed a new concept in serving Chinese cuisine. To honor our one year anniversary we are personally inviting you and a friend for a complimentary Cocktail

Chinese Cuisine
and Piano Bar
California at Polk
Valet Parking
441-7337
Present this card for
complimentary
Cocktail

CLIENT. Red's Restaurant—Chinese Cuisine & Piano Bar TOOLS. QuarkXPress, Illustrator
ART DIRECTOR/DESIGNER/ILLUSTRATOR. Warren Welter PRINTING. Technigraphics

★★★Red's One-Year Anniversary invitation

Second Floor

MICRO

141

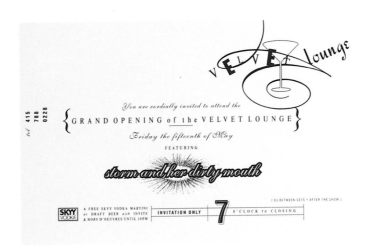

You are cordially invited to attend the

{ GRAND OPENING of the VELVET LOUNGE }

Friday the fifteenth of May

FEATURING

storm and her dirty mouth

tel 415 788 0228

(DJ BETWEEN SETS • AFTER THE SHOW)

SKYY VODKA

A FREE SKYY VODKA MARTINI
or DRAFT BEER with INVITE
& HORS D'OEUVRES UNTIL 10PM

INVITATION ONLY | 7 | O'CLOCK to CLOSING

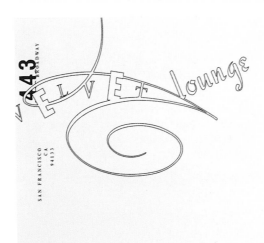

143 BROADWAY

SAN FRANCISCO
CA
94133

CLIENT. Velvet Lounge
ART DIRECTOR. Steve Barretto
TOOLS. Illustrator, Macintosh

PAPER. Somerset Textured Softwhite
250g/m²
PRINTING. Classic Letterpress

★★★Velvet Lounge Grand Opening invitation

Flux

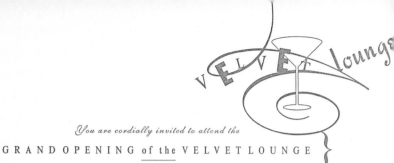

tel 415
788
0228

You are cordially invited to attend the

{ GRAND OPENING of the VELVET LOUNGE }

Thursday the fourteenth of May

FEATURING

 (DJ BETWEEN SETS + AFTER THE SHOW)

| HOSTED BAR & HOR 'DEURVES UNTIL 10PM | INVITATION ONLY | 7 | O'CLOCK *to* CLOSING |

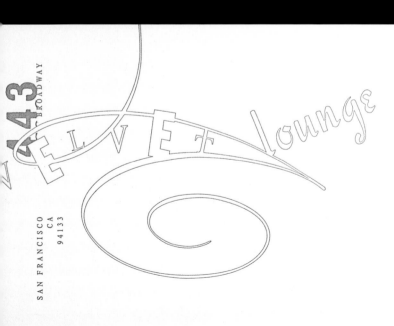

1443 BROADWAY

SAN FRANCISCO
CA
94133

CLIENT. Kitchen K—A Design Gallery
ART DIRECTORS. Jeff Fabian, Sam Shelton

DESIGNERS. Beth Clawson, Mike Joosse, Jenny Harrington, Scott Rier, Kate Kroener, Natalie Politis, Jackie Ratsch, Beverly Hunter

TOOLS. QuarkXPress, Macintosh
PAPER. Cardboard
PRINTING. Triangle looseleaf

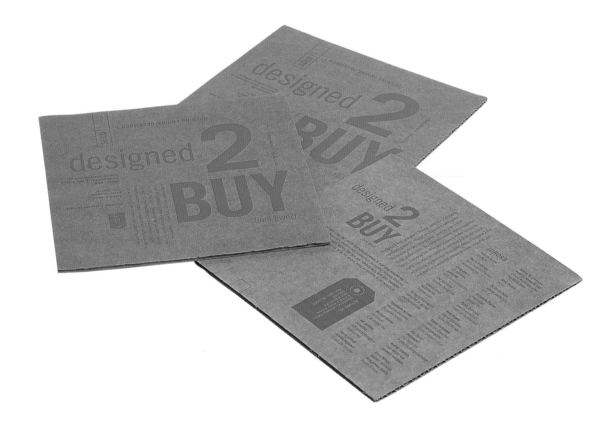

★★★Designed 2 Buy announcement

Kinetik Communication Graphics

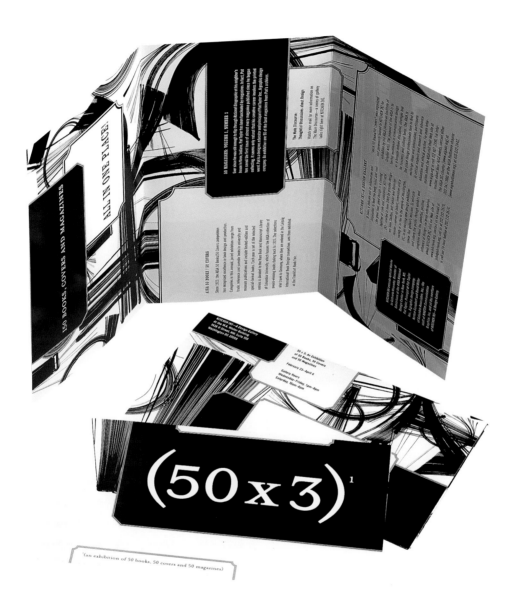

'(an exhibition of 50 books, 50 covers and 50 magazines)

CLIENT. Kitchen K—A Design Gallery DESIGNERS. Beth Clawson, Mike Joosse, TOOLS. QuarkXPress, Macintosh

Jenny Harrington, Scott Rier, Kate Kroener PAPER. Potlatch McCoy

ART DIRECTORS. Jeff Fabian, Sam Shelton

★★★(50x3) Exhibition announcement

Kinetik Communication Graphics

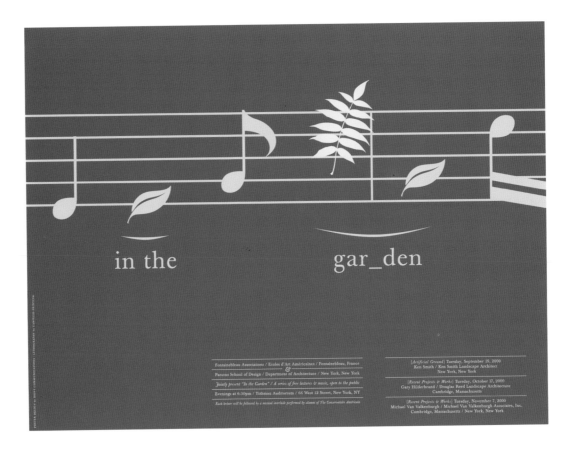

CLIENT. Fontainebleau Associations
ART DIRECTOR. Michael Graziolo
DESIGNER. Eiji Tsuda

TOOLS. Illustrator, Macintosh
PAPER. Finch Opaque

★★★Fountainebleau poster

Drive Communications

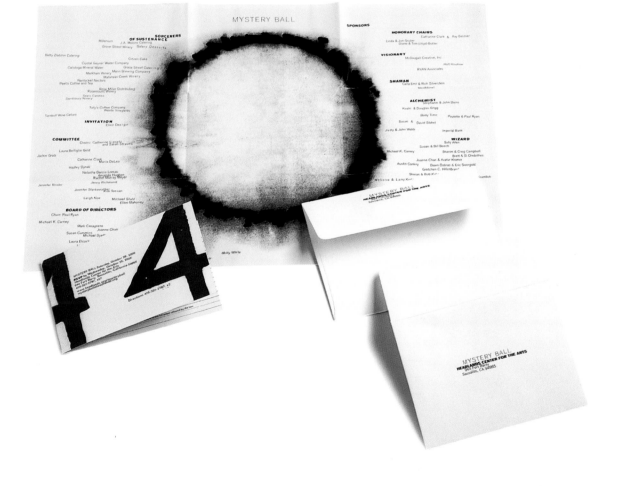

MYSTERY BALL

PAPER. 50# White Husky Offset (invite), 80# White Exact
Vellum Bristol (reply card), Sundance Felt (A2 and A6 eps)
PRINTING. Norco Printing

CLIENT. Headlands Center for the Arts
ART DIRECTOR. Jennifer Jerde
DESIGNER. Holly Holmquist

★★★Mystery Ball 2000 invitation

Elixir Design

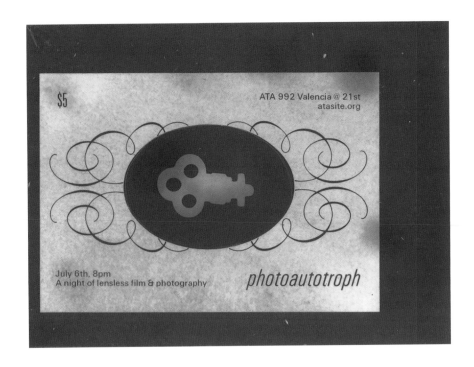

CLIENT. Artists' Television Access (ATA)
ART DIRECTOR. Aaron Cruse
DESIGNERS. Aaron Cruse, Austin Lee, Alexis Bravos

TOOL. Copy camera
MATERIALS. Clip art, small objects, chemistry, sun
PRINTING. Cyanotype (blueprint)

★★★ Photoautotroph invitation

Dead Letter Type

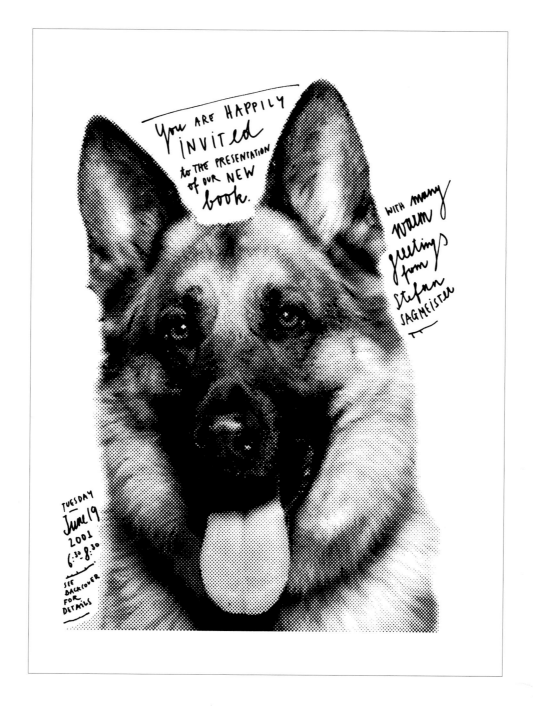

CLIENT. Stefan Sagmeister

ART DIRECTOR/DESIGNER/ ILLUSTRATOR. Stefan Sagmeister

TOOLS. Illustrator, Photoshop

PAPER. Newsprint

PRINTING. Newsprint

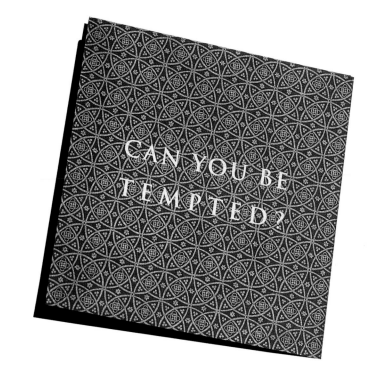

CAN YOU BE
TEMPTED?

CLIENT. Studio Yu
DESIGNER. Jeff Matz

TOOLS. Photoshop, QuarkXPress
PRINTING. Offset, silver ink

MICRO

150

★★★Eden invitation

Lure Design, Inc.

PLEASE JOIN US FOR A NIGHT OF DARING TEMPTATIONS ON SATURDAY, OCTOBER 28TH 2000 AT THE SAPPHIRE. PLEASE BE DRESSED TO KILL IN YOUR FAVORITE COSTUME – BE IT FETISH OR FANTASY– AND PRESENT OUR ENCLOSED SIGNATURE FLOGGER FOR ENTRY TO THIS EXCLUSIVE EVENING OF DELIGHT. ENTICING ENTERTAINMENT SHALL BE PROVIDED BY A HOST OF HEAVENLY CREATURES TO SEDUCE YOUR SENSES. SINFUL INFUSIONS WILL BE SERVED TO TANTALIZE YOUR PALATE AND REMOVE YOUR INHIBITIONS. FANTASIES BEGIN REALIZATION AT 11:15PM. $25 IS REQUESTED PER GUEST TO ATTEND THIS EXTREMELY PRIVATE EVENT WITH LIMITED SPACE AVAILABLE. PLEASE CALL 407 592 6949 BY OCTOBER 21ST TO CONFIRM YOUR EXPERIENCE IN THE GARDEN OF EDEN AND TO RECEIVE FURTHER INSTRUCTIONS FOR ENTRY.

FROM THE EXOTIC TO THE EROTIC

5

VOLUME
THE THIRD DIMENSION
packaging / promotions / books / CDs / menus / doorstop

★★★"Sorry We're Open" doorstop

MATTER

CLIENT. MATTER
ART DIRECTORS. Rick Griffith,
Jason C. Otero
DESIGNER. Rick Griffith

TOOLS. Illustrator, Macintosh
MATERIALS. Poured plastic, resin, sand
FABRICATOR. James Stoltzenbach

CLIENT. Harvard University Design School

ART DIRECTOR/DESIGNER. Nelida Nassar

TOOL. QuarkXPress

PAPER. Lenticular Film Mounted in Card Stock

PRINTING. Silkscreen

★★★Hong Kong Defining the Edge

Nassar Design

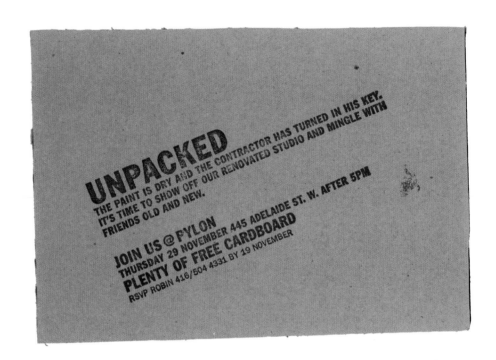

UNPACKED
THE PAINT IS DRY AND THE CONTRACTOR HAS TURNED IN HIS KEY.
IT'S TIME TO SHOW OFF OUR RENOVATED STUDIO AND MINGLE WITH
FRIENDS OLD AND NEW.

JOIN US @ PYLON
THURSDAY 29 NOVEMBER 445 ADELAIDE ST. W. AFTER 5PM
PLENTY OF FREE CARDBOARD
RSVP ROBIN 416/504 4331 BY 19 NOVEMBER

★★★Pylon party invite

Pylon Design, Inc.

CLIENT. Pylon Design, Inc.
ART DIRECTORS. Scott Christie, Kevin Hoch
DESIGNER. Erin Boyce

TOOLS. QuarkXPress, Macintosh
MATERIALS. Black ink, rubber stamp
PRINTING. Rite Rubber Stamp Company

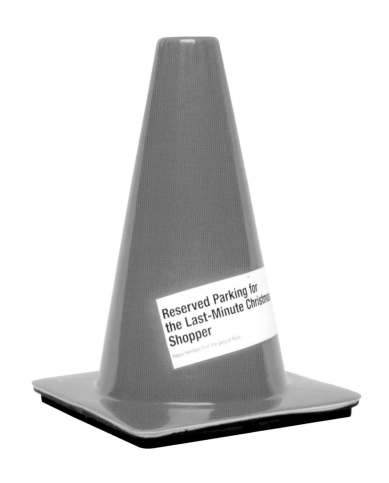

Reserved Parking for
the Last-Minute Christmas
Shopper

Happy Holidays from the gang at Pylon

CLIENT. Pylon Design, Inc.
ART DIRECTORS. Scott Christie, Kevin Hoch
DESIGNER. Scott Christie

TOOLS. QuarkXPress, Macintosh
PAPER. Avery Label
PRINTING. Laser printer

★★★Christmas promo

Pylon Design, Inc.

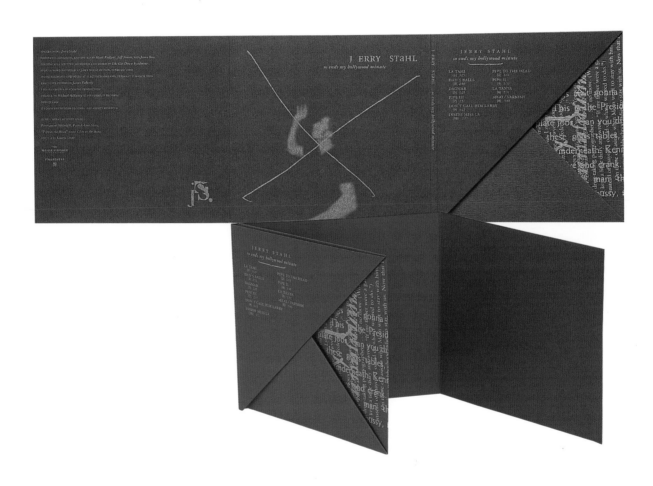

★★★Jerry Stahl CD jacket

Lure Design, Inc.

CLIENT. Figurehead Records
DESIGNER. Jeff Matz
TOOLS. Illustrator, Photoshop

PAPER. Fox River Teton
PRINTING. Offset, silver ink,
special fold

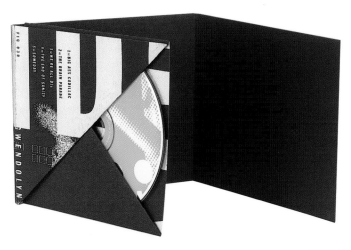

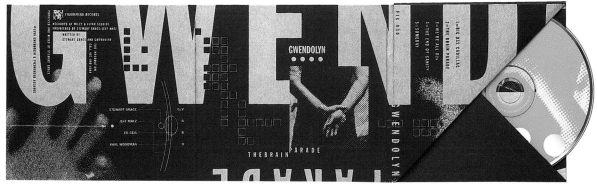

CLIENT. Figurehead Records
DESIGNER. Jeff Matz
TOOLS. Illustrator, Photoshop

PAPER. French Speckletone
PRINTING. Silkscreen, silver ink,
special fold

★★★Gwendolyn CD jacket

Lure Design, Inc.

VOLUME
159

1C/6

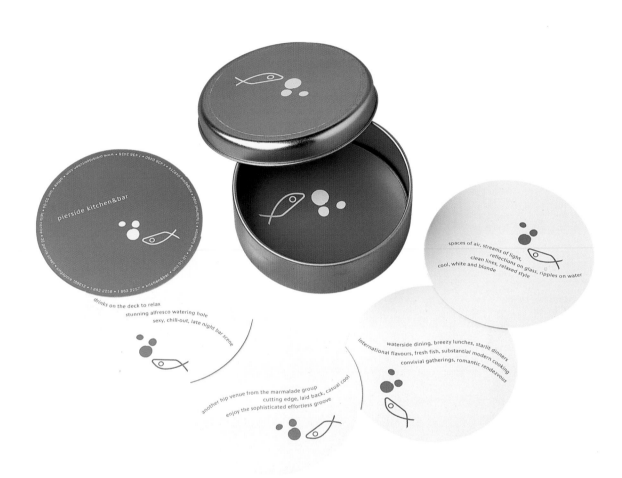

pierside kitchen&bar

drinks on the deck to relax
stunning alfresco watering hole
sexy, chill-out, late night bar scene

another hip venue from the marmalade group
cutting edge, laid back, casual cool
enjoy the sophisticated effortless groove

spaces of air, streams of light,
reflections on glass, ripples on water
clean lines, relaxed style
cool, white and blonde

waterside dining, breezy lunches, starlit dinners
international flavours, fresh fish, substantial modern cooking
convivial gatherings, romantic rendezvous

★★★Pierside media kit

Design Asylum Pte. Ltd.

CLIENT. Pierside Kitchen & Bar
ART DIRECTOR. Christopher Lee
DESIGNER/ILLUSTRATOR. Kai

TOOLS. Freehand, Macintosh
PAPER. Mirrorkote Sticker, Art Card
PRINTING. Metallic Ink

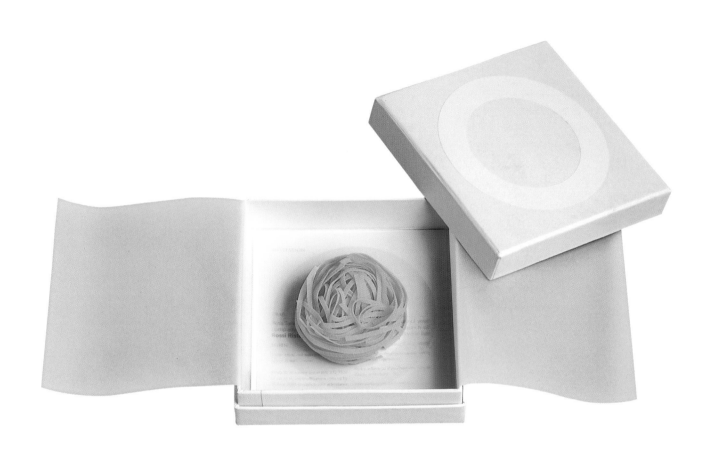

CLIENT. Rossi Ristorante/Enoteca
ART DIRECTOR. Christopher Lee
DESIGNER. Larry Peh

TOOLS. Freehand, Macintosh
PAPER. GSK Transparent/Maple Ivory
PRINTING. Metallic ink

★★★Rossi Ristorante opening

Design Asylum Pte. Ltd.

VOLUME
161

1 C/G

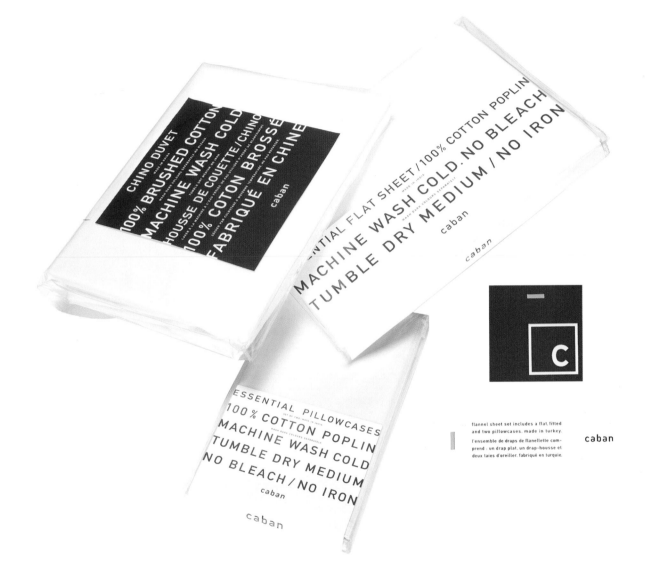

ESSENTIAL FLAT SHEET / 100% COTTON POPLIN
MACHINE WASH COLD. NO BLEACH
TUMBLE DRY MEDIUM / NO IRON
caban
caban

CHINO DUVET
100% BRUSHED COTTON
MACHINE WASH COLD
HOUSSE DE COUETTE/CHINO
100% COTON BROSSÉ
FABRIQUÉ EN CHINE
caban

ESSENTIAL PILLOWCASES
100% COTTON POPLIN
MACHINE WASH COLD
TUMBLE DRY MEDIUM
NO BLEACH / NO IRON
caban
caban

c

flannel sheet set includes a flat, fitted
and two pillowcases. made in turkey.

l'ensemble de draps de flanellette com-
prend : un drap plat, un drap-housse et
deux taies d'oreiller. fabriqué en turquie.

caban

CLIENT. Caban
ART DIRECTOR.
Vanessa Eckstein
DESIGNERS. Vanessa
Eckstein, Frances
Chen, Stephanie Yung
TOOLS. Illustrator, Macintosh
PAPER. Hammermill Via
PRINTING. C.J. Graphics

SENTIAL PILLOWCASES

SET OF TWO / MADE IN INDIA

0 % COTTON POPLIN

WASH DARK COLOURS SEPARATELY.

CHINE WASH COLD

MBLE DRY MEDIUM

BLEACH / NO IRON

caban

caban

caban

L'EAU FROIDE. NE PAS REPAS

SÉCHER PAR CULBUTAGE À MOYENNE TEMPÉRATURE

LAVER À LA MACHINE

NE PAS UTILISER D'AGENT DE BLANCHIMENT.

100% POPELINE DE COT

LAVER LES COULEURS FONCÉES SÉPARÉMENT.

ENSEMBLE DE DEU

FABRIQUÉ EN INDE

100% BR

WASH

MACHIN

HOUSSE

LAVER À LA MACHINE À L

100% CO

SÉCHER PAR CULB

FABRI

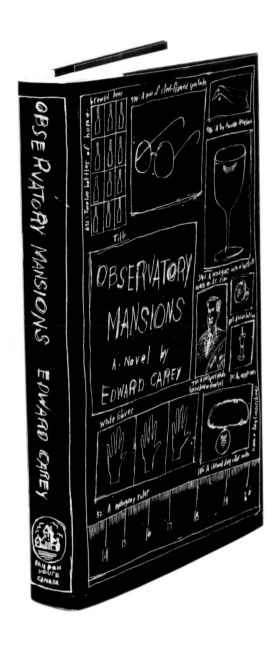

★★★Observatory Mansions

Pylon Design, Inc.

CLIENT. Random House of Canada
ART DIRECTOR. Scott Christie
DESIGNERS. Scott Christie, Gary Clement

TOOLS. Pencil, QuarkXPress, Macintosh
PAPER. Matte Coated

?pregnancy test

1 test • 99% Accurate • Result in 4 minutes

superdrug

CLIENT. Superdrug **DESIGNER.** Clare Poupard
ART DIRECTOR. Garrick Hamm **PRINTING.** Lithography

★★★Pregnancy test packaging

Williams Murray Hamm

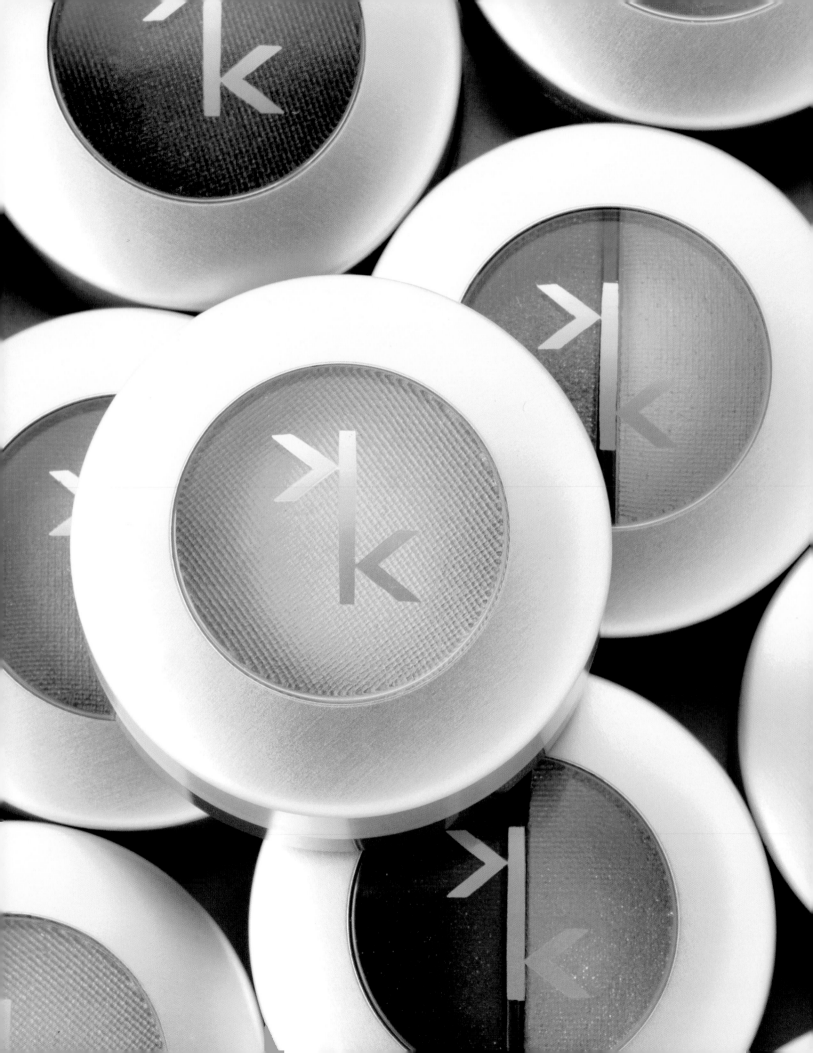

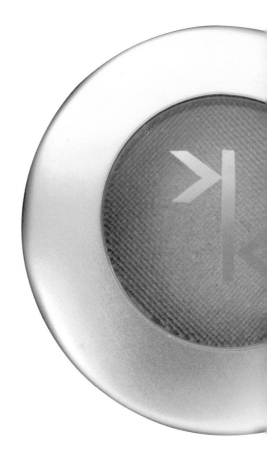

CLIENT. Superdrug
ART DIRECTORS. David Turner, Bruce Duckworth

DESIGNER. Janice Davison
TOOLS. Freehand, Macintosh

★★★Kolor packaging

Turner Duckworth

VOLUME 5

167

★★★Actia invite

Actia

CLIENT. Actia
ART DIRECTOR/DESIGNER. Anne-Lise Dermenghem
TOOLS. Illustrator, QuarkXPress

PAPER. Thibièrge Évanescent,
 Comar
PRINTING. Aquaform

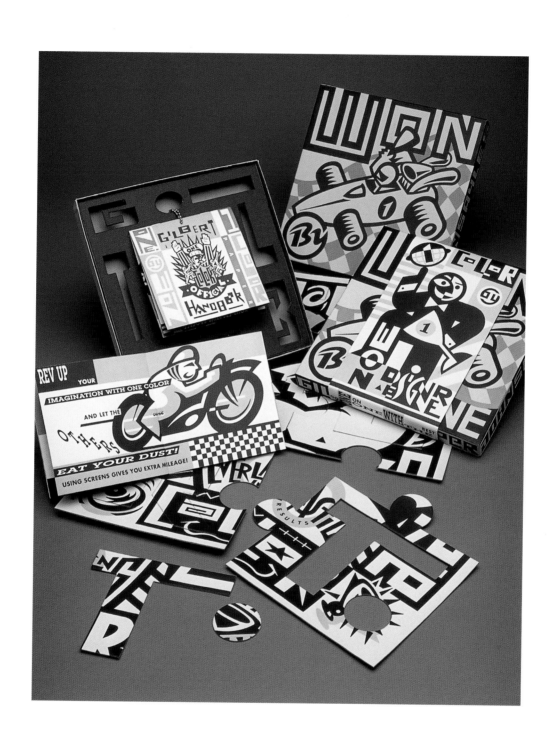

CLIENT. Gilbert Paper
ART DIRECTOR/DESIGNER/
ILLUSTRATOR. John Sayles

TOOLS. Illustrator, Macintosh
PAPER. Gilbert Oxford
PRINTING. Offset

★★★"One by One" paper promo
Sayles Graphic Design

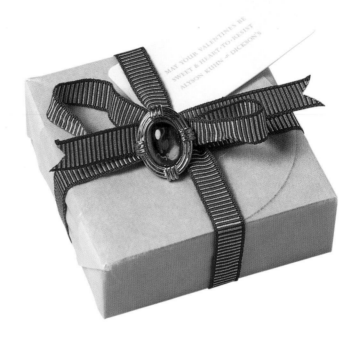

MAY YOUR VALENTINES BE
SWEET & HEART-TO-RESIST
ALYSON KUHN ∞ DICKSON'S

CLIENT. Dickson's, Inc.
ART DIRECTOR. Jennifer Jerde
DESIGNER. Nathan Durrant
PAPER. Crane's Kid Finish
Pearl White 134#
PRINTING. Engraved bisque

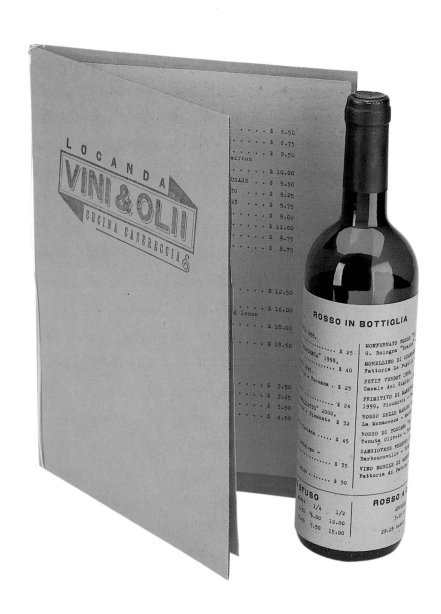

CLIENT. Locanda Vini & Olii
ART DIRECTOR. Matteo Bologna
DESIGNERS. Andrea Brown, Matteo Bologna

TOOLS. Freehand, Macintosh
PRINTING. Sioux Printing

★★★Locanda Vini & Olii

Mucca Design

VOLUME
171

★★★Volleyball book

Jennifer Sterling Design

CLIENT. Regis
ART DIRECTOR/DESIGNER. Jennifer Sterling
PHOTOGRAPHER. Marko Lavrisha
TOOLS. Illustrator, Photoshop
PAPER. Fox River
PRINTING. H. MacDonald Printing

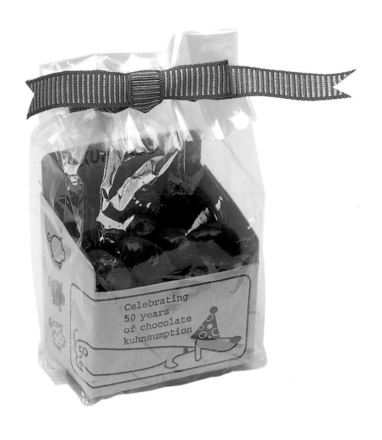

Celebrating
50 years
of chocolate
kuhnsumption

★★★Inkuhnabula Bon-bon box

Liska & Associates

CLIENT. Alyson Kuhn
ART DIRECTOR. Steve Liska
DESIGNER. Christina Nimry
PAPER. Light Impressions
Slide Box
PRINTING. Letterpress

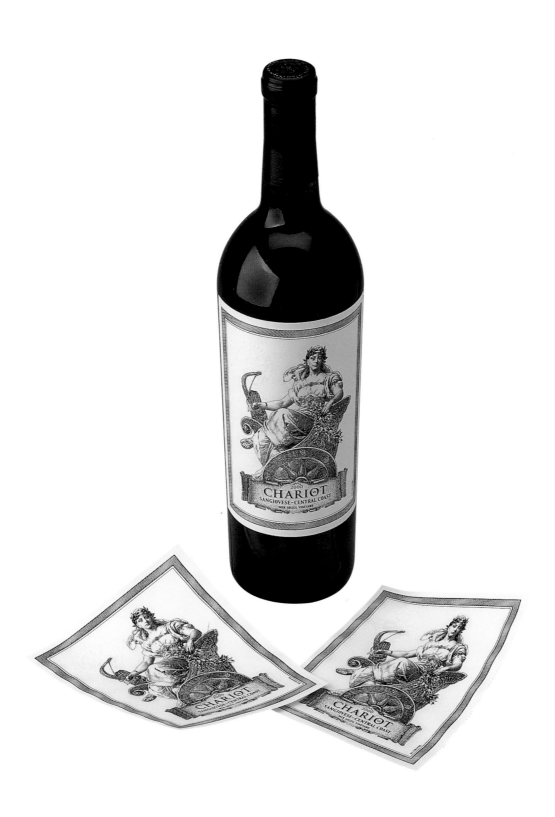

CLIENT. Jim Neal Wines
ART DIRECTOR. Tony Auston
DESIGNERS. Tony Auston, Chaim
 Blomquist, Don Whelan

ILLUSTRATOR. David Laverty
TOOLS. Illustrator, Macintosh
PAPER. Mohawk Superfine Softwhite
PRINTING. Dickson's, Inc.

★★★Chariot Wine label

Auston Design Group

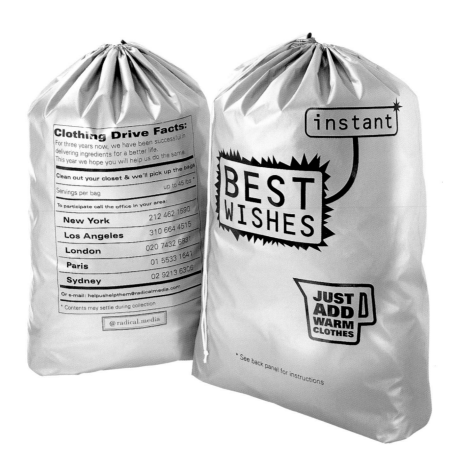

The text on the bags:

Clothing Drive Facts:
For three years now, we have been successful in delivering ingredients for a better life. This year we hope you will help us do the same.

Clean out your closet & we'll pick up the bags
Servings per bag up to 45 lbs *
To participate call the office in your area:

New York	212 462 1590
Los Angeles	310 664 4515
London	020 7432 6831
Paris	01 5533 1641
Sydney	02 9213 6306

Or e-mail: helpushelpthem@radicalmedia.com

* Contents may settle during collection

@radical.media

instant

BEST WISHES

JUST ADD WARM CLOTHES

* See back panel for instructions

★★★Instant Best Wishes
@radical.media

CLIENT. @radical.media
ART DIRECTOR/DESIGNER. Rafael Esquer
COPYWRITERS. Angela Fung, Geoff Reinhard
MATERIALS. Canvas Drawstring Bag
TOOLS. Illustrator, Macintosh
PRINTING. Silkscreen, Porcupine Products

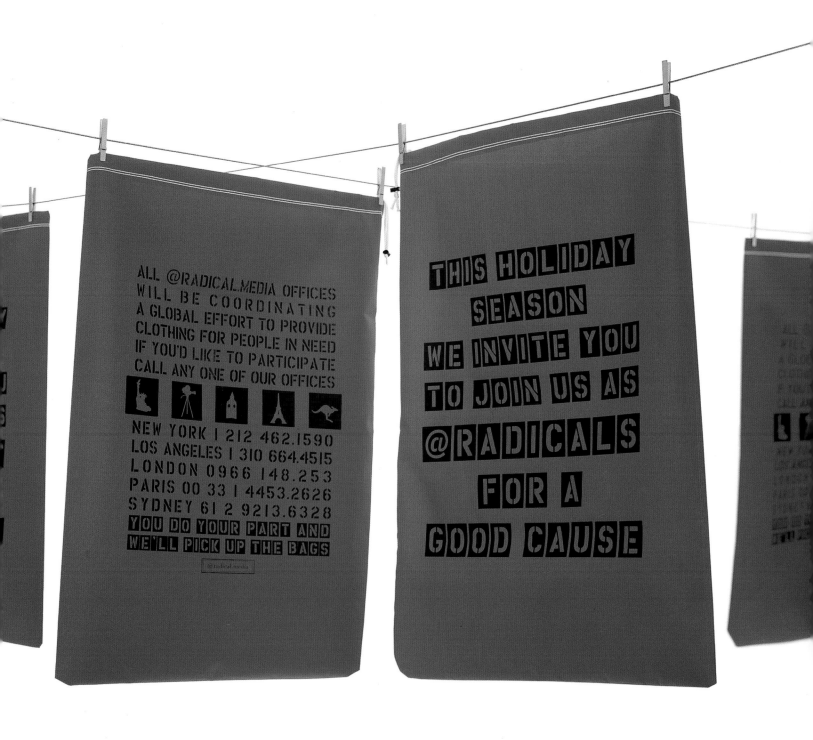

ALL @RADICAL.MEDIA OFFICES
WILL BE COORDINATING
A GLOBAL EFFORT TO PROVIDE
CLOTHING FOR PEOPLE IN NEED
IF YOU'D LIKE TO PARTICIPATE
CALL ANY ONE OF OUR OFFICES

NEW YORK 1 212 462.1590
LOS ANGELES 1 310 664.4515
LONDON 0966 148.253
PARIS 00 33 1 4453.2626
SYDNEY 61 2 9213.6328
YOU DO YOUR PART AND
WE'LL PICK UP THE BAGS

@radical.media

THIS HOLIDAY
SEASON
WE INVITE YOU
TO JOIN US AS
@RADICALS
FOR A
GOOD CAUSE

CLIENT. @radical.media
ART DIRECTOR/DESIGNER. Rafael Esquer
COPYWRITER. Jon Kamen

MATERIALS. Canvas
TOOLS. Illustrator, Macintosh
PRINTING. Silkscreen, Porcupine Products

***For a Good Cause
@radical.media

★★★Ologi packaging

Turner Duckworth

CLIENT. Golden State International
ART DIRECTORS. David Turner, Bruce
Duckworth

DESIGNER. David Turner
TOOLS. Freehand, Macintosh
MATERIALS. Aluminum, Rubber

Balsamic Vinegar
200ml

CLIENT. Heals
ART DIRECTOR. Garrick Hamm
DESIGNER/ILLUSTRATOR. Fiona Curran
PRINTING. Lithography

★★★Balsamic Vinegar

Williams Murray Hamm

CDA COLLECTION
ONE-COLOR WORK FROM CHEN DESIGN ASSOCIATES

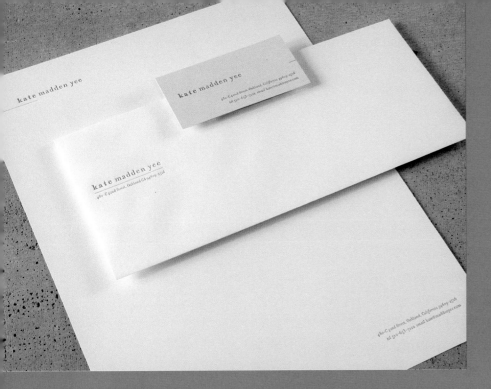

CLIENT. Kate Madden Yee
ART DIRECTOR. Josh Chen
DESIGNER. Kathryn Hoffman

TOOLS: QuarkXPress, Macintosh
PAPER. Champion Benefit
PRINTING. Full Circle Press

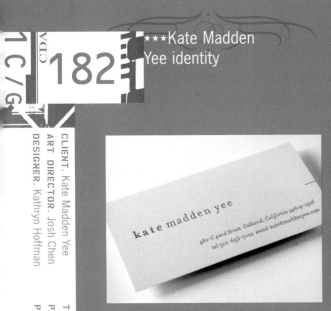

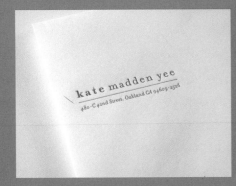

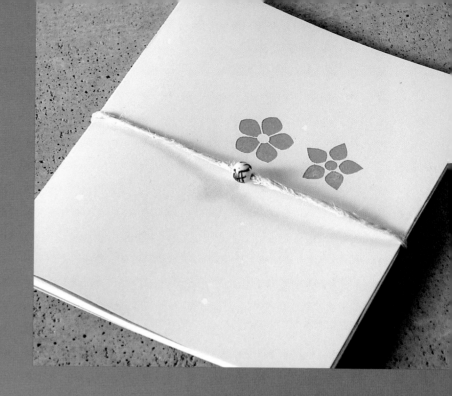

CLIENTS. Jacqueline Quintanilla, Albert Lin
DESIGNER. Max Spector
TOOLS. Illustrator, QuarkXPress, Macintosh

MATERIALS. French Frostone, Crane's Kid Finish, Handmade Paper, Twine, Bead
PRINTING. Full Circle Press (letterpress), Rubber hand stamp (red)

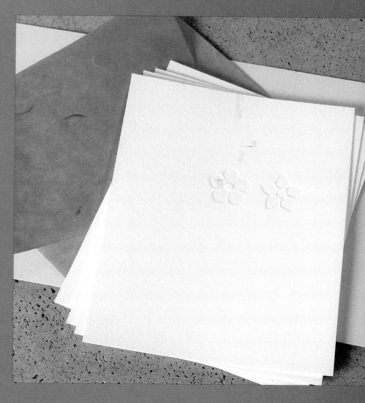

***CED News
alumni
magazine

CLIENT. College of Environmental Design,
UC Berkeley
ART DIRECTORS. Kathryn Hoffman, Josh Chen
DESIGNERS. Max Spector, Kathryn Hoffman

TOOLS. Illustrator, Photoshop, QuarkXPress,
Macintosh
PAPER. 60# Hammermill Accent Opaque Lustre White
PRINTING. UC Printing Services

2000

2001

JOSEPH ESHERICK
1914-1998

1999

PAPER. Curious Popset,
Crane's Crest
PRINTING. Full Circle Press

CLIENT. Maya Spector
DESIGNER. Max Spector
TOOLS. Illustrator, Macintosh

Maya Spector 3751 Bay Road, Menlo Park, CA 94025

Maya Spector

***Maya Spector
identity

Maya Spector

oral traditions

STORYTELLING
POETRY
RITUAL

mayaspector@hotmail.com 650 329 1415

CLIENT. The Walden School
ART DIRECTOR. Josh Chen
DESIGNERS. Josh Chen, Max Spector,
Christopher DeWinter

TOOLS. Illustrator, Photoshop, QuarkXPress,
Macintosh
PAPER. Finch
PRINTING. Oscar Printing Company

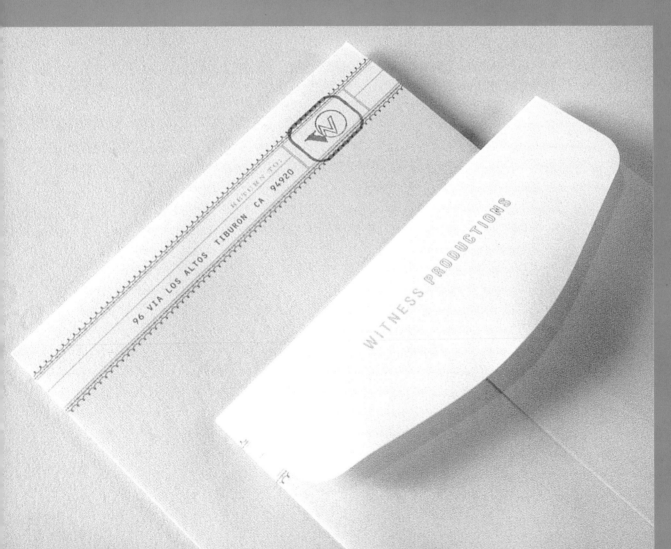

WITNESS PRODUCTIONS

LOIS MELKONIAN
[415]
350-8161
LM@witnessproductions.org

ADDRESS
96 VIA LOS
TIBURON C
94920

TELEPHONE
415 383 9703

FACSIMILE
415 388 1916

96 VIA LOS ALTOS TIBURON CA 94920 RETURN TO:

WITNESS PRODUCTIONS

CLIENT. Witness Productions, LLC
ART DIRECTOR. Josh Chen
DESIGNER. Max Spector
TOOLS. Illustrator, Macintosh

PAPER. Strathmore Pure Cotton
PRINTING. Oscar Printing Company (offset),
Rubber hand stamp (red)

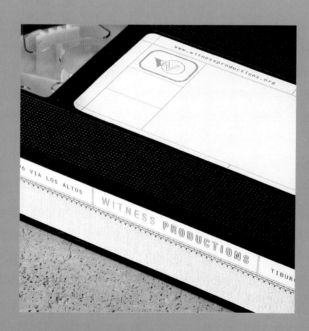

★ @RADICAL.MEDIA
435 Hudson Street, 6F
New York, NY 10014 USA
212.462.1500
212.462.1600 f
radicalmedia.com
{176, 177}

★ A DAY IN MAY DESIGN
3053 Fillmore Street, #182
San Francisco, CA 94123 USA
415.614.0005
415.614.0006 f
adayinmay.com
{12, 68-69, 133, 134, 135, 138}

★ ACTIA
7 rue Édouard Nortier
Neuilly/Seine 92200
FRANCE
+33 14.738.2905
actia.asso.fr
{168}

★ ALR DESIGN
3007 Park Avenue, #1
Richmond, VA 23221 USA
804.359.2697
804.359.2697 f
alrdesign.com
{56, 139}

★ AMY KNAPP DESIGN
54 Scenic Avenue
San Anselmo, CA 94960 USA
415.482.0541
415.482.0539 f
{43}

★ ANVIL GRAPHIC DESIGN
2611 Broadway
Redwood City, CA 94063 USA
650.261.6090
650.261.6094 f
hitanvil.com
{128}

★ ARKZIN D.O.O.
Ilica 176/I
Zagreb, HR-10000 CROATIA
+13 85.1.3777 866
+13 85.1.3777 867 f
arkzin.com
{106}

★ AUFULDISH & WARINNER
183 The Alameda
San Anselmo, CA 94960 USA
415.721.7921
415.721.7965 f
aufwar.com
{60-61}

★ AUSTON DESIGN GROUP
101 S. Coombs Street, Studio P
Napa, CA 94559 USA
707.226.9010
707.226.9013 f
austondesign.com
{29, 175}

★ BARBARA BROWN
MARKETING & DESIGN
2873 Pierpont Boulevard
Ventura, CA 93001 USA
805.667.6671
805.667.6674 f
bbmd-inc.com
{130-131}

★ BECKER DESIGN
225 E. St. Paul Avenue,
Suite 300
Milwaukee, WI 53154 USA
414.224.4942
414.224.4943 f
beckerdesign.net
{42}

★ BLØK DESIGN
822 Richmond Street W., #301
Toronto, ON M6J 1C9 CANADA
416.203.0187
416.203.0075 f
{36, 71, 72-73, 162-163}

★ BOWHAUS DESIGN GROUPE
340 N. 12th Street, Suite 314
Philadelphia, PA 19107 USA
215.733.0603
215.733.0661 f
bowhausdesign.com
{37}

★ CABRA DISEÑO
417 14th Street
San Francisco, CA 94103 USA
415.626.6336
415.626.6330 f
cabradiseno.com
{101-103}

★ CAHAN & ASSOCIATES
171 Second Street, Fifth Floor
San Francisco, CA 94105 USA
415.621.0915
415.621.7642 f
cahanassociates.com
{26-27, 58-59}

★ CHEEVERS
319 SW Washington, Suite 1200
Portland, OR 97204 USA
503.228.5522
503.228.5521 f
cheevers.com
{116-117}

★ CHEN DESIGN ASSOCIATES
589 Howard Street, Fourth Floor
San Francisco, CA 94105 USA
415.896.5338
415.896.5339 f
chendesign.com
{182-183, 184-185, 186, 187,
188-189, 192}

★ CHOPLOGIC
2014 Cherokee Parkway
Louisville, KY 40204 USA
502.451.0383
{24}

★ DEAD LETTER TYPE
1072 Folsom Street, #452
San Francisco, CA 94103 USA
415.621.4508
deadlettertype.com
{35, 148}

★ DECKER DESIGN
14 W. 23rd Street, Third Floor
New York, NY 10010 USA
212.633.8588
212.633.8599 f
deckerdesign.com
{34}

★ DESIGN ASYLUM PTE. LTD.
46B Club Street S
(069 423) SINGAPORE
+65 324.8264
+65 324.8265 f
{160, 161}

★ DRIVE COMMUNICATIONS
133 W. 19th Street, Fifth Floor
New York, NY 10011 USA
212.989.5103
212.989.6307 f
drivecom.com
{38, 146}

★ ELIXIR DESIGN, INC.
2134 Van Ness Avenue
San Francisco, CA 94109 USA
415.834.0300
415.834.0101 f
elixirdesign.com
{16-17, 25, 28, 40, 136, 147, 170}

★ ELLEN BRUNI-GILLIES
DESIGN
16 Elm Avenue
Kentfield, CA 94904 USA
415.482.8786
415.785.3987 f
{126}

★ FLUX
601 Fourth Street, Suite 117
San Francisco, CA 94107 USA
415.974.5034
415.974.0548 f
fluxstudio.com
{22, 46, 47, 142-143}

★ FORM FÜNF
Graf Moltke Straße 7
28203 Bremen GERMANY
+49 421 70 30 74
+49 421 70 06 17 f
form5.de
{31-33}

★ FRIEDHELM PLASSMEIER
Danziger Strasse 6
Brakel, Westfalia 33034
GERMANY
+49 5.272.8275
+49 5.272.8275 f
{92}

★ GEE + CHUNG DESIGN
38 Bryant Street, Suite 100
San Francisco, CA 94105 USA
415.543.1192
415.543.6088 f
geechungdesign.com
{20}

★ GEORGE TSCHERNY, INC.
238 East 72nd Street
New York, NY 10021 USA
212.734.3277
212.734.3278 f
{14-15}

★ GILLESPIE DESIGN, INC.
32 W. 31st Street, Studio 7
New York, NY 10001 USA
212.239.1520
212.239.1503 f
gillespiedesign.com
{74}

★ HOMESPUN DESIGN
1010 D Street
Petaluma, CA 94952 USA
707.766.8058
707.769.8362 f
{127}

★ IGOR MASNJAK DESIGN
L'industrie 3
Lausanne, Vaud 1005
SWITZERLAND
41 79.681.7354
{62-67}

★ JEANNE MACIJOWSKY
DESIGNS
5426 Hermit Terrace
Philadelphia, PA 19128 USA
215.509.7364
215.509.7364 f
{30}

★ JENNIFER STERLING
DESIGN
P.O. Box 475428
San Francisco, CA 94147 USA
415.924.8238
415.924.8448 f
jsterlingdesign.com
{112, 113, 172-173}

★ JOSÉ J. DIAS DA S. JUNIOR
Rua Nilza M. Martins, 340/103
São Paulo, SP 05628-010
BRAZIL
+55 11.9603.5022
+55 11.3936.4857 f
{23}

★ KINETIK COMMUNICATION
GRAPHICS
1436 U Street, NW, Suite 404
Washington, DC 20009 USA
202.797.0605
202.387.2848 f
kinetikcom.com
{144, 145}

★ KO CRÉATION
6300 avenue du Parc, #420
Montréal, QC H2V 4H8
CANADA
514.278.9550
514.278.7153 f
kocreation.com
{48-49, 50-51, 75}

★ KROG
Krakovski Nasip 22
1000 Ljubljana SLOVENIA
+38 6.1.426.5761
+38 6.1.426.5761 f
{129}

★ LISKA & ASSOCIATES
515 N. State Street, 23rd Floor
Chicago, IL 60610 USA
312.644.4400
312.644.9650 f
liska.com
{174}

★ LOVE COMMUNICATIONS
533 South 700 East
Salt Lake City, UT 84102 USA
801.519.8880
801.519.8884 f
{52-55}

★ LURE DESIGN, INC.
P.O. Box 53144
Orlando, FL 32853 USA
407.835.1699
407.835.1698 f
luredesigninc.com
{19, 96, 97, 98-100, 104, 105,
150-151, 158, 159}

★ MATTER
1614 15th Street, Fourth Floor
Denver, CO 80202 USA
303.893.0330
303.893.0329 f
matter.ws
{118, 119, 120, 121, 154}

★ MIX PICTURES GRAFIK
Weihermatte 5
Sempach CH-6204
SWITZERLAND
+41 41.460.15.45
+41 41.460.15.04 f
mixpictures.ch
{122, 123}

★ MO'NIA
Rua José Rocha 985 R/CH,
Mafamude
Vila Nova De Gaia 4430-122
PORTUGAL
+351 22.379.2295
{76-77}

★ MONSTER DESIGN
P.O. Box 938
Kirkland, WA 98083 USA
425.828.7853
425.576.8055 f
monsterinvasion.com
{132}

★ MORLA DESIGN
463 Bryant Street
San Francisco, CA 94107 USA
415.543.6548
415.543.7214 f4 f
morladesign.com
{88-91}

★ MUCCA DESIGN
315 Church Street, Fourth Floor
New York, NY 10013 USA
212.965.9821
212.207.7904 f
muccadesign.com
{57, 171}

★ NASSAR DESIGN
11 Park Street
Brookline, MA 02446 USA
617.264.2862
617.264.2861 f
{18, 21, 84, 140, 155}

★ NIKLAUS TROXLER DESIGN
Postfach
Willisau, CH:6130
SWITZERLAND
+41 41.970.27.31
+41 41.970.32.31 f
troxlerart.ch
{108, 109, 110}

★ PUBLIC
10 Arkansas, Suite L
San Francisco, CA 94107 USA
415.863.2541
415.863.8954 f
publicdesign.com
{70, 137}

★ PYLON DESIGN, INC.
445 Adelaide Street W.
Toronto, ON M5V 1T1
CANADA
416.504.4331
416.504.4113 f
pylondesign.ca
{39, 156, 157, 164}

★ RED ALERT VISUALS
2455 Folsom Street
San Francisco, CA 94110 USA
415.640.7625
redalertvisuals.com
{114, 115}

★ SAGMEISTER INC.
222 W. 14th Street, #15A
New York, NY 10011 USA
212.647.1789
212.647.1788 f
stealingeyeballs.net/sagmeister/
{78-81, 82-83, 149}

★ SAVINI DESIGN
106 Walnut Street
San Francisco, CA 94118 USA
415.441.5535
{13}

★ SAYLES GRAPHIC DESIGN
3701 Beaver Avenue
Des Moines, IA 50310 USA
515.279.2922
515.279.0212 f
saylesdesign.com
{169}

★ SECOND FLOOR
443 Folsom Street
San Francisco, CA 94105 USA
415.495.3491
415.777.0764 f
secondfloor.com
{141}

★ SHOEHORN DESIGN
1010 E. 11th Street
Austin, TX 78702 USA
512.478.4190
512.477.5104 f
shoehorndesign.com
{111}

★ STUDIO 455
455 Mariposa Street
San Francisco, CA 94107 USA
415.626.0522
415.626.8922 f
{41}

★ STUDIO INTERNATIONAL
Buconjićeva 43
Zagreb HR-10000 CROATIA
+385 137.60171
studio-international.com
{94-95}

★ TOM & JOHN:
A DESIGN COLLABORATIVE
1298 Haight Street, #5
San Francisco, CA 94117 USA
415.621.0444
415.551.1220 f
tom-john.com
{85, 93}

★ TURNER DUCKWORTH
164 Townsend Street, #8
San Francisco, CA 94107 USA
415.495.8691
415.495.8692 f
turnerduckworth.com
{166-167, 178}

★ UNIVERSITY OF
WASHINGTON SCHOOL OF ART
Visual Communication
Design Program
Box 353440
Art Bldg., Room 102
Seattle, WA 98195-3440 USA
206.685.2773
206.685.1657 f
{107}

★ WILLIAMS MURRAY HAMM
Heals Building
Alfred Mews
London W1P 9LB ENGLAND
+44 207.255.3232
creatingdifference.com
{165, 179}

Chen Design Associates, San Francisco, was established in 1991 by principal and creative director Joshua Chen. From a one-man basement bedroom operation, CDA has grown into a multi-disiciplinary group that provides strategic vision and creative content for clients in arts and entertainment, education, health care, non-profit, publishing, and technology sectors.

The firm creates work that is conceptually driven, solidly written, passionately designed, and uniquely photographed and illustrated. CDA's body of work includes branding and identity, annual reports, packaging, print collateral, and Web sites.

ABOUT THE AUTHOR

THE STUDIO AT CDA IS A PLACE FOR COLLABORATION. EDUCATION. AND INVENTION. LONGEVITY IS A KEY VALUE THAT EXTENDS TO CDA'S RELATIONSHIP WITH CLIENTS AND VENDORS ALIKE. PRACTICING A PHILOSOPHY OF RESPONSIVENESS AND RELEVANCY. CDA FOSTERS A CREATIVE PROCESS THAT ENGENDERS MUTUAL RESPECT AND UNDERSTANDING WHILE EXCEEDING BUSINESS OBJECTIVES AND PUSHING CREATIVE STANDARDS.

CDA is regularly recognized with national and regional awards for design excellence, including nods from *Print*'s Regional Design Annual, *HOW*'s Self-Promotion and International Design Competitions, The Summit Creative Awards, The Communicator Awards, and the San Francisco Advertising Club. Their work has been selected for inclusion in prominent design books, including *Small Graphics*, *Touch Graphics: The Power of Tactile Design*, from Rockport Publishers, and the newly published *Graphically Speaking* from HOW Design Books. This is the first book they've authored *and* designed for Rockport Publishers.